Rankin
Male Nudes

Male Nudes. It makes you wonder, doesn't it? It's definitely intriguing. This is not the smooth, rolling landscape of the female body – this is a much bigger challenge – the awkward, jutting affront of the male. According to Rankin,'the female form is much more beautiful to photograph, which I think has something to do with the history of images. But also, women haven't got a dangly cock and bollocks between their legs.'

Rankin's women looked pensive, teasing, erotic. There was the woman in a shopping trolley. There was the woman in the back of a car. Taking pictures of naked women, for Rankin, is like 'unlocking a door'; as soon as a woman begins to take her clothes off, a vast cultural force is unleashed. The photographer's task is to handle this force creatively.

But male nudes are much more difficult. Here is serious, raw nakedness. Many photographers of the male nude dispense with the penis altogether – we've all seen plenty of pictures of men posing side-on, or in the shower, behind a sheet of water, or cut off at the waist. Visually speaking, the penis is at its most potent when it is absent, when it is implied. In the flaccid flesh, hanging to one side or the other, doing nothing much, it is almost always a disappointment.

But Rankin faces up to the penis. He takes it on. Of naked men, he says, 'I suddenly realised I don't find them attractive. I don't feel intimidated by them, because I don't feel like I'm being voyeuristic at all. I started to become quite neutral about shooting them, which I found really great.'

Why are male bodies intimidating? One of the reasons for this is that, for the last few centuries, our gaze has been directed away from men, towards women. We are unused to seeing unclothed men. On the other hand, the female body is, as the American writer John Updike puts it, 'the prime aesthetic object… a masterpiece of market design.' Look at the way we use the female body to sell things; look at the way the things we buy, from cars to furniture, reproduce its soft curves. For centuries we have been happy to see the female body static, objectified, divided into its constituent parts. Every day we walk or drive past posters which depict sections of femaleness – just legs, just breasts.

We're not used to looking at the male body in the same way. Whereas we see the female body as a magnet, an attractor, we see the male body as a machine, a thing capable of force or offence. We are not used to seeing men exposed, contorted, trussed up, pinned out for inspection. We like men to be in the middle of doing things. We look for movement. This is why, to our eyes, erotic pictures of men look ridiculous; naked men fishing or climbing or washing the car do not look attractive. They don't work, just as pictures of disembodied male legs don't work, and just as men lying down, motionless, or posing on beds or chairs do not look like they are getting on with the job of being men.

How do we deal with naked men? They arouse confusing emotions. We are afraid of them, certainly. On the other hand, their nakedness renders them strangely impotent. Looking at these pictures reveals an important fact: they are more naked than their counterparts, naked women. A naked woman is, in a way, not naked, but dressed with several centuries of imagery; when we look at her, we clothe her with the ideas we already have in our minds – ideas about her power to attract, her sexiness, her shame. Naked women come already supplied with a narrative. Naked men need explaining – we intuitively don't understand, don't automatically expect and accept their exposure. Naked women are such a ubiquitous part of our mindset that they have pubic hairstyles.

Men do not, on the whole, have pubic hairstyles. They either have their bits showing, or not showing. Outside the world of homoerotic photography, male nudes have no narrative. They are just blokes, with their clothes off. The photographer and the subject both know that, for their efforts to have any meaning at all, they must add something. And that something is often humour.

Rankin adds a lot of humour to his male nudes. In one picture, John Moysen is holding a magnifying glass in front of his penis. In another, Martin Bleasdale is putting his penis in a frankfurter bap and squeezing mustard on it. 'That one makes me laugh quite a lot,' says Rankin. Doing the same thing to a woman, he agrees, would not be on. There is a picture of Anthony Agbaje holding sharp nail extensions in front of his penis. There is a diptych – Paul Facer poses, nude, and then poses again, having dipped his penis in an ice bucket, to show how much the cold makes it shrink.

Vince Clarke is standing in front of what appears to be a garden shed. He looks like he forgot his clothes on the way to get some tools. Another subject, Charlie Strand, has covered his naked body with ice; the picture is a play on the fact that he is Icelandic. Alex McFadyen is dressed in a kilt, which is being blown up by a gust of wind – a reference to Marilyn Monroe. In this situation, Monroe looked vulnerable and sexy; Alex looks at best like a prankster, or possibly someone who should be arrested.

Here are men who are being deeply honest about themselves. Aware that they might be seen as a threat, they are threatening themselves. Aware that they might look tragic, they have agreed to look comic. Bear in mind what a tough assignment this must have been. These men, climbing on things, holding things in front of their crotches, do not look sultry or sexy. In the end, they are fascinating. Bereft of the accessories available to female nudes – the dancing poles, the stretched pantyhose, the thongs, the voluptuous breasts, and the pubic hairstyles – they are straining to do their best. Take your hat off to them.

William Leith

When I first started taking photographs, I used to joke that it was an easy way to meet girls.

Funnily enough photography is an easy way to meet girls. It's easy in the sense not only that I come regularly in contact with them, but also that the process of meeting and photographing them is easy.

There's an unspoken dynamic that's well established between a male photographer and a female nude. It's one that says it's ok for the photographer to flirt with the subject, because the subject is flirting with the camera and is capable of being empowered by it. It says it's acceptable to photograph naked women, and so generally everyone feels comfortable about the entire process.

With female nudes I tried to turn this exchange on its head by giving women control of the way they wanted to be seen.

The male nude isn't yet a subject that the public is comfortable with. Women are still taught to think of exposed men as something that should be confined to private situations or as most men change to situations. Most men dislike seeing images of naked men, mainly I feel because they believe it questions their sexuality, whilst also challenging it. How big is yours?

It took me some time to actually appreciate the male body, to stop being scared of dicks (especially comparative sizes), and to understand why the public become so upset at even the mention of a penis!

The experience was entirely frustrating and rewarding in equal measures. The men were, in general, a little more eccentric than the women I'd photographed for the first Nudes book. But then I came to see that was exactly the point – that for a man to pose naked there's the assumption that there's something abnormal about him. Once I got to know them, (mostly) they seemed more normal. My perception of them was as much about my attitude as their personalities.

Eventually the subjects and their ideas began to intrigue me and the process became easier. Once I'd become adjusted to the process, I did my best to make the men feel relaxed, and it felt like I'd finally overcome my fear of the male form. That it took several months of photographing a series of naked men to do so made me realise just how much of a taboo the subject still is, and I wonder, will looking at the images be enough to adjust others' perceptions? Or will the only people who choose to look at this book be those who are already at ease with the stark male?

I'd like to dedicate this book to all of the brave men who exposed themselves to my camera.

Rankin

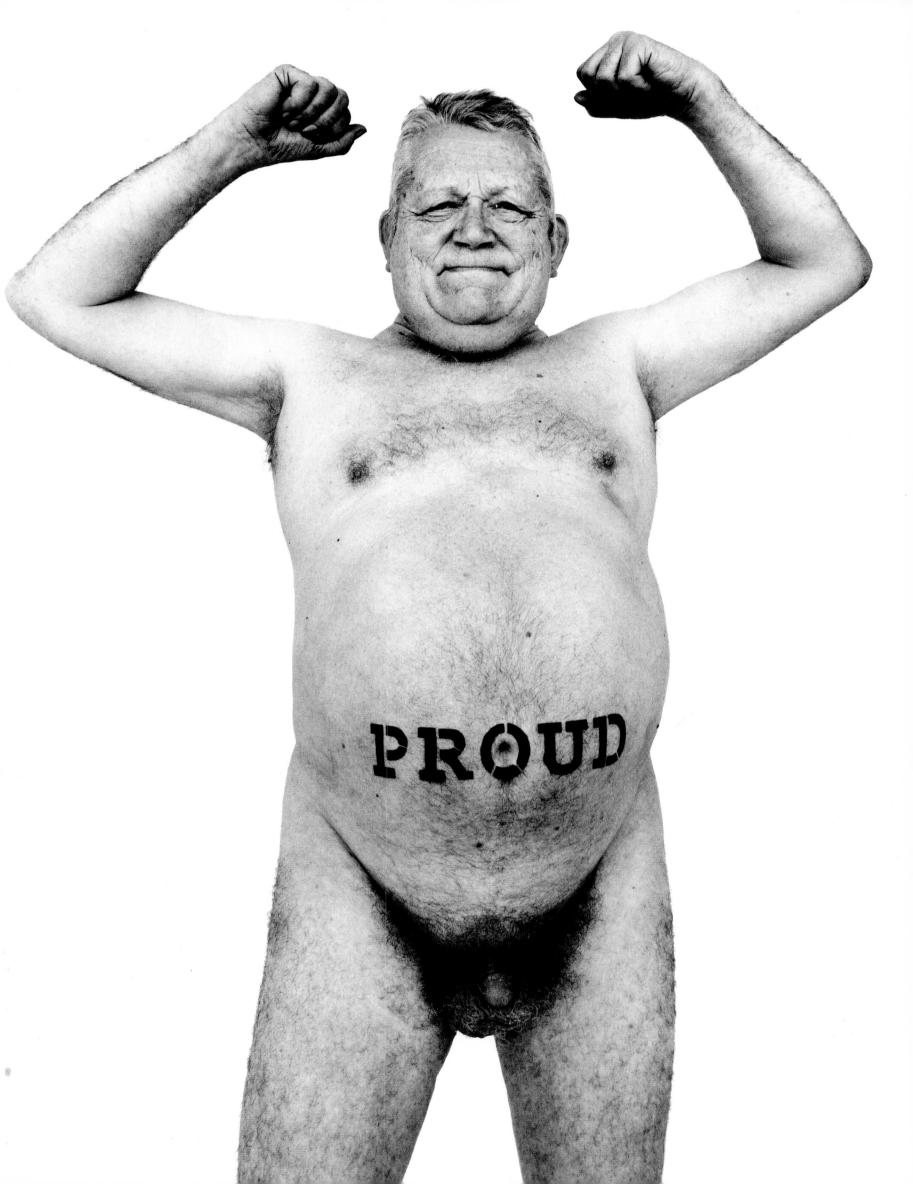

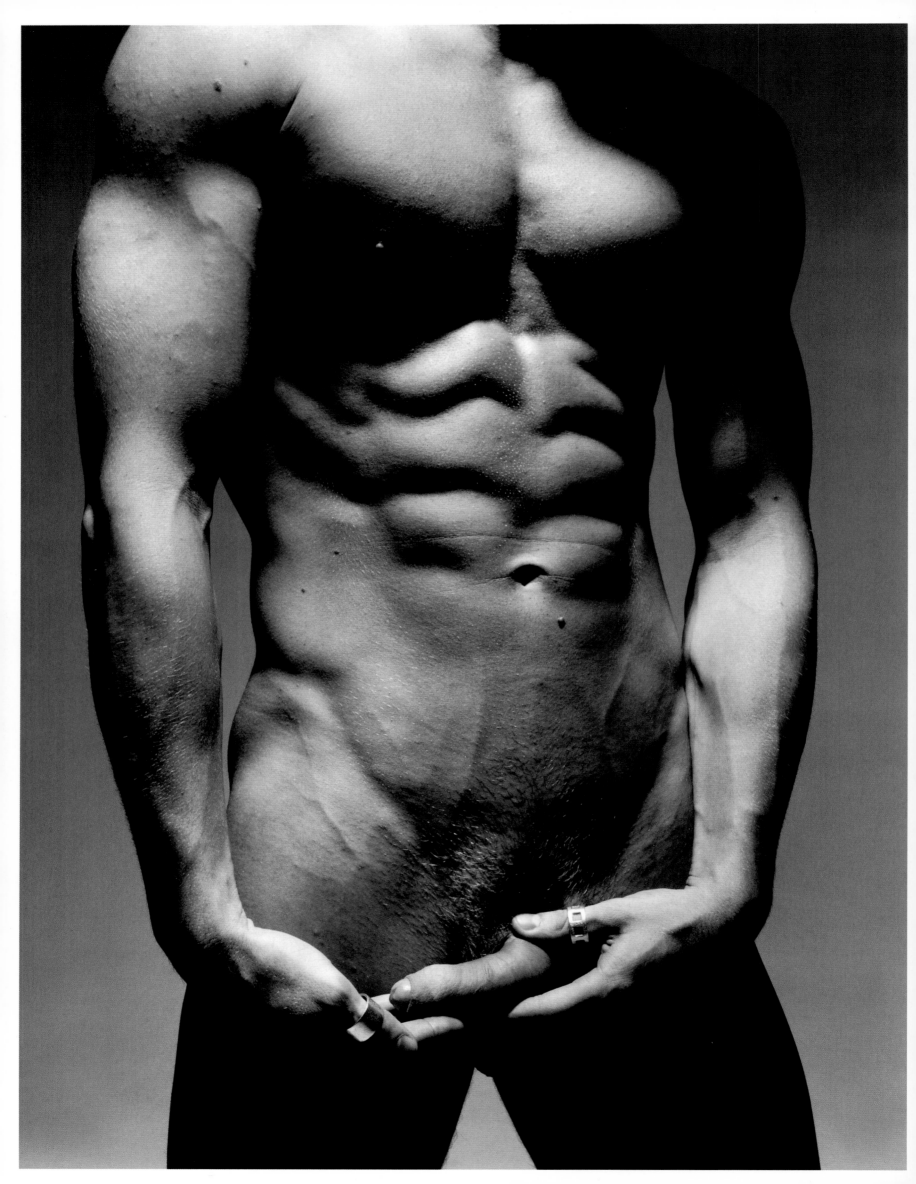

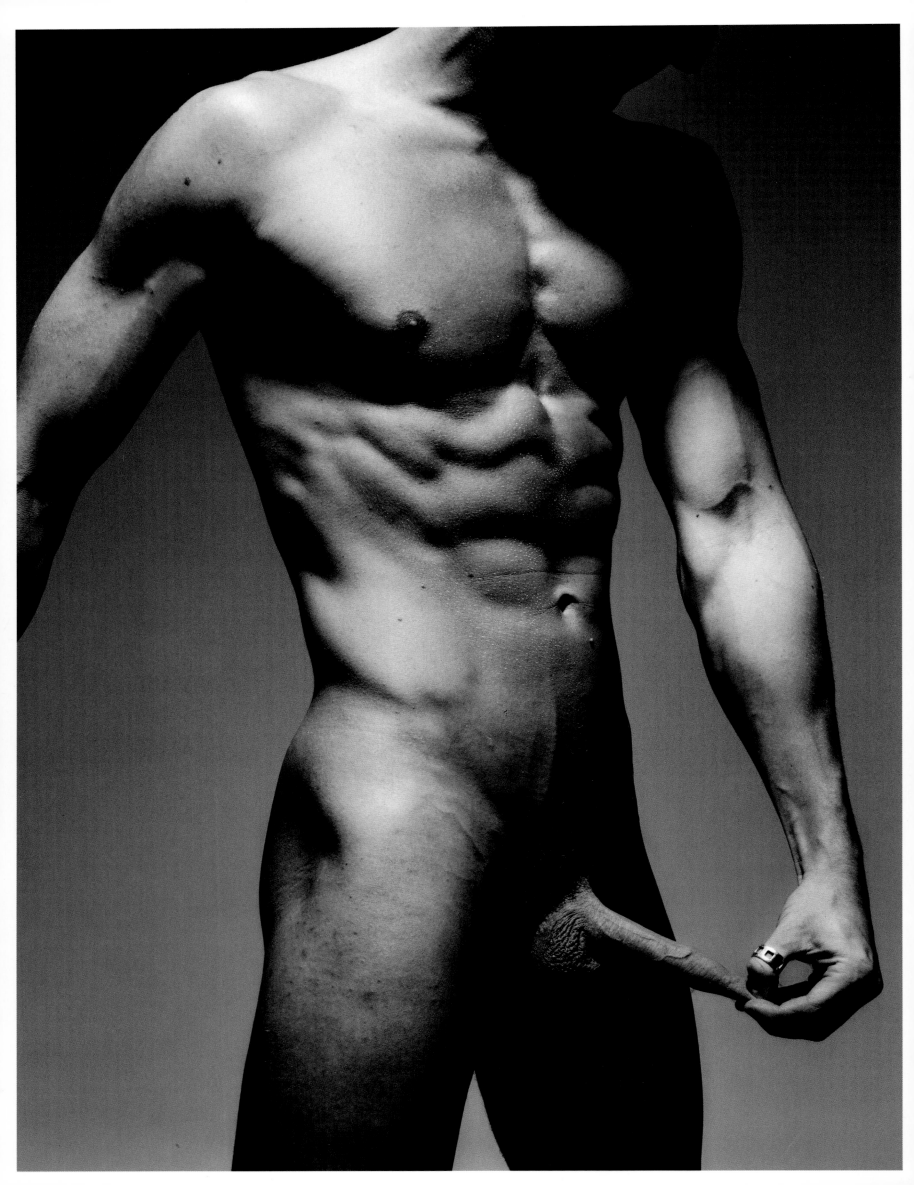

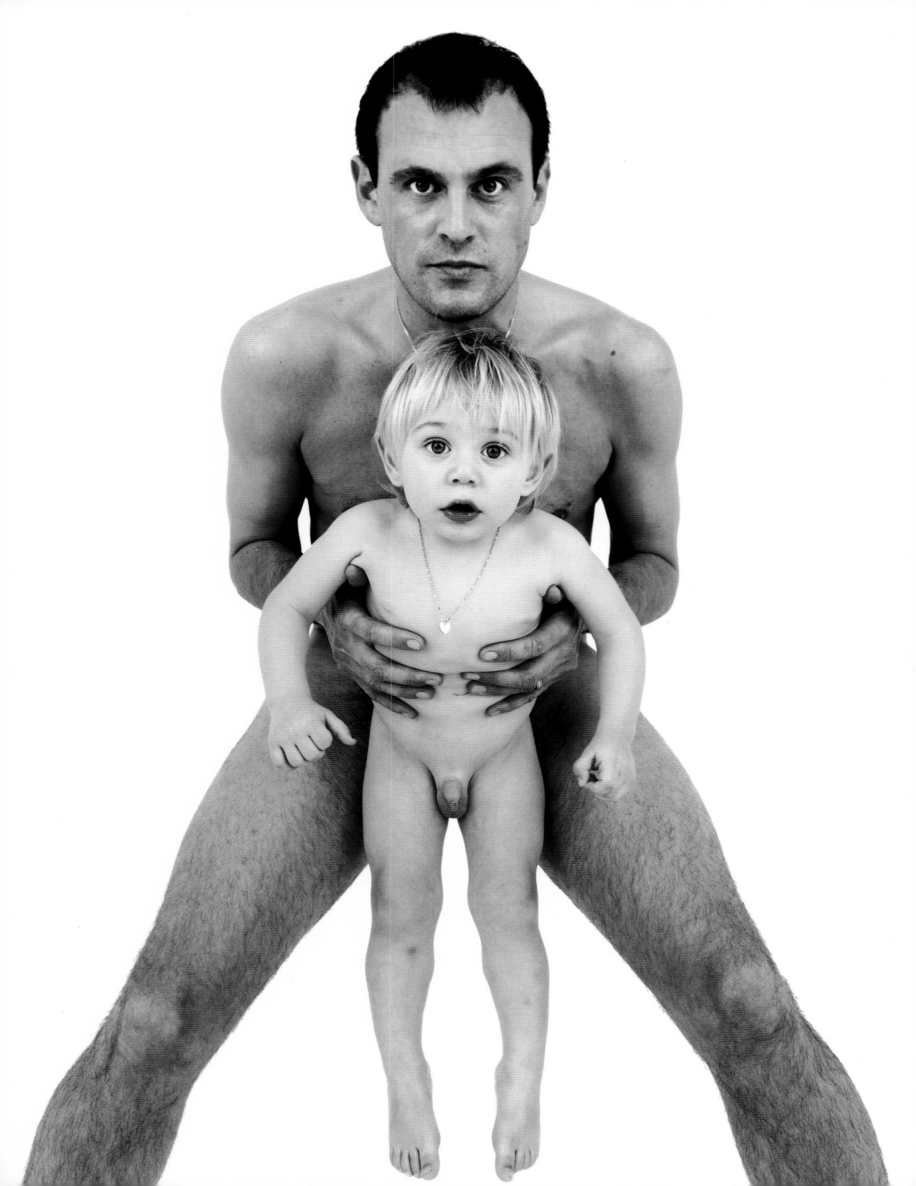

16

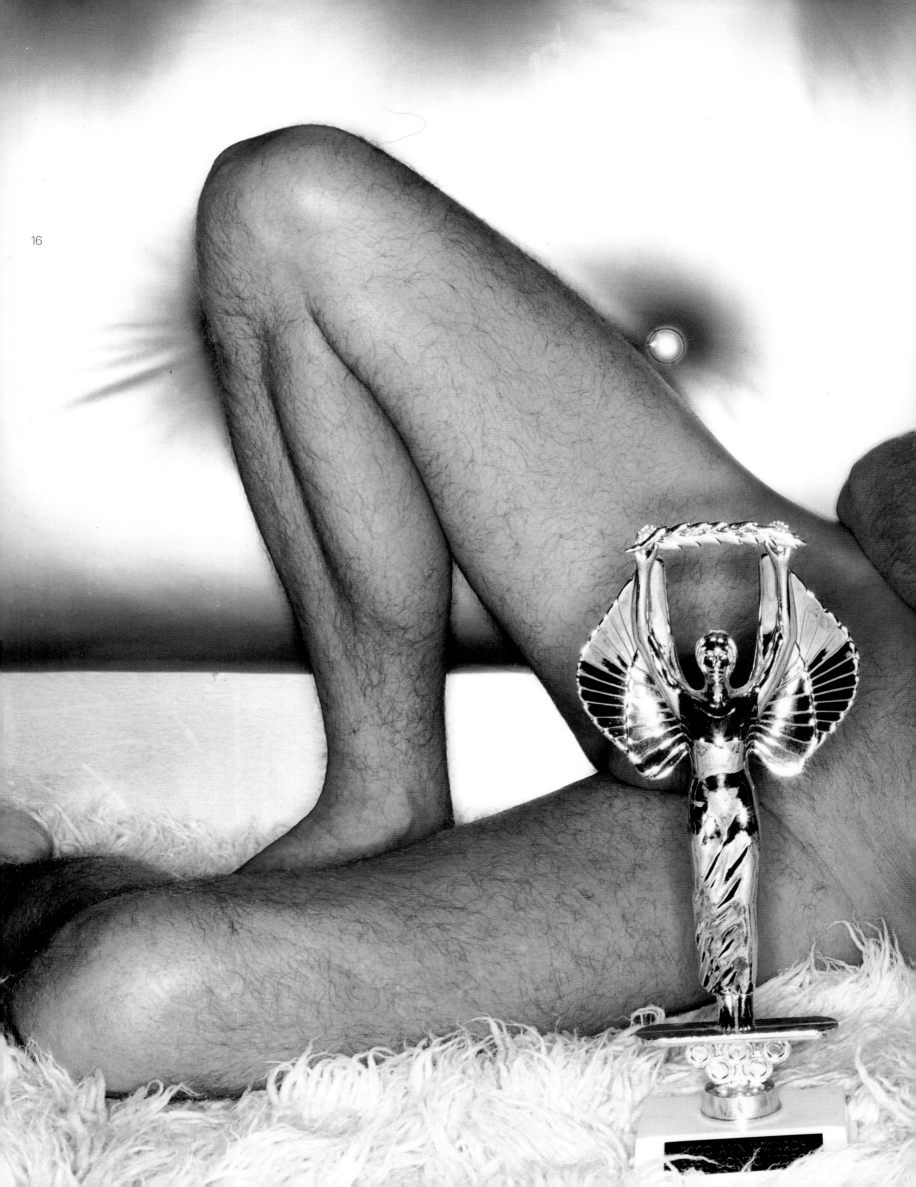

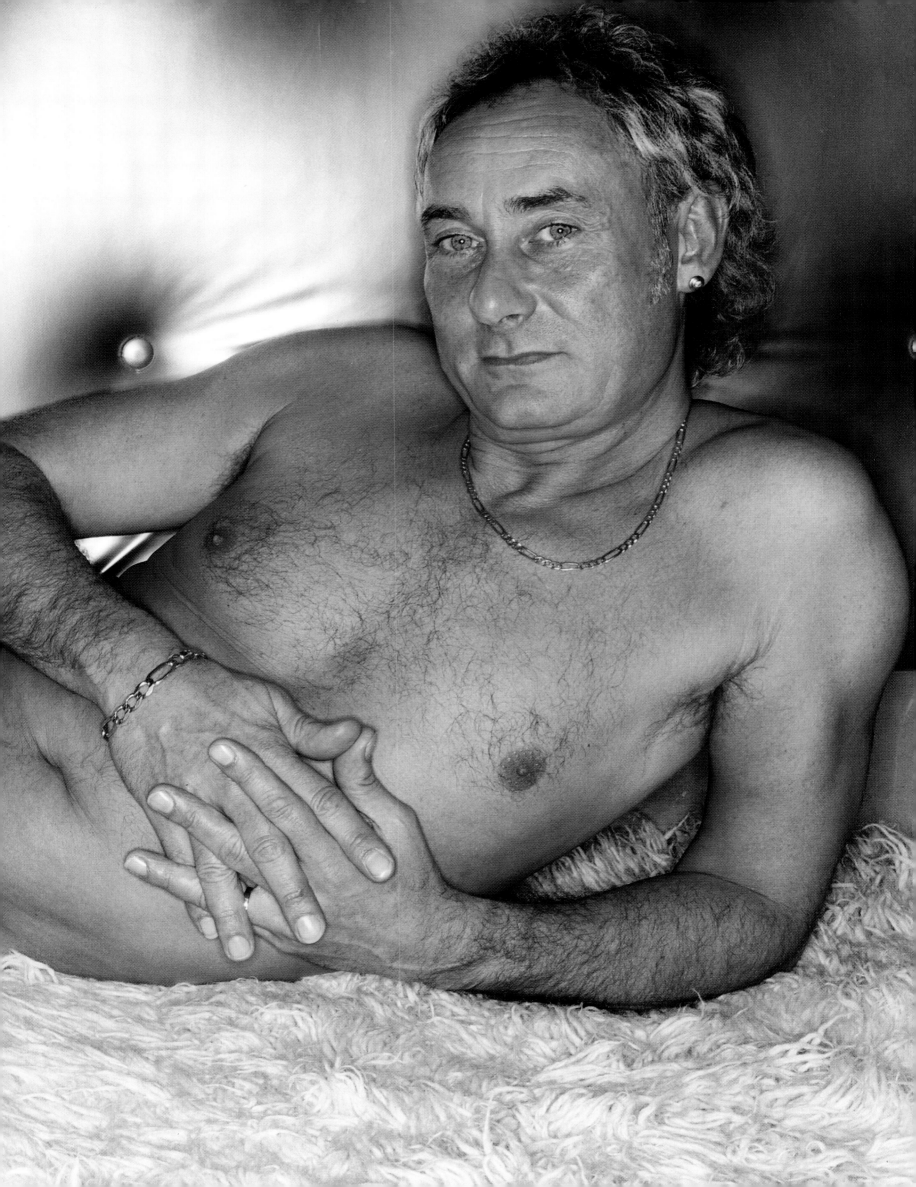

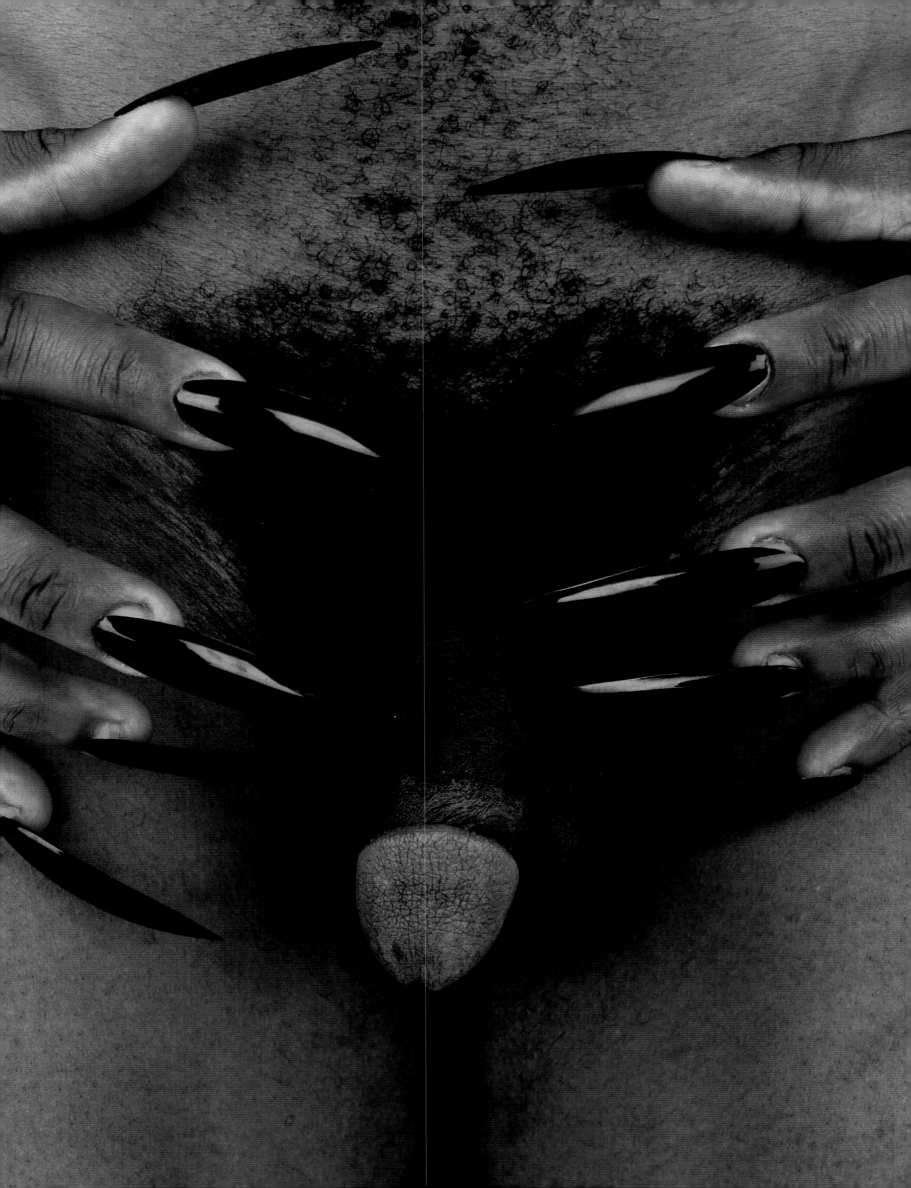

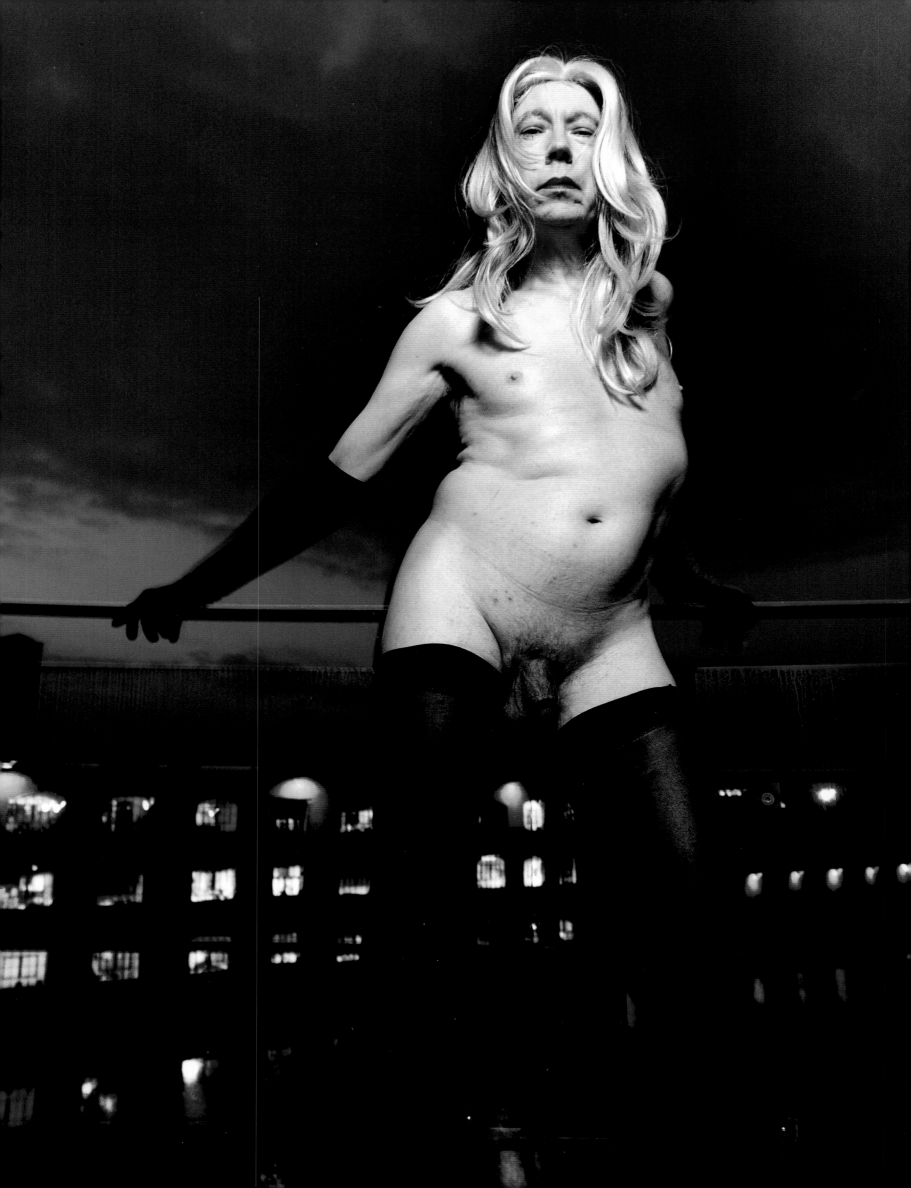

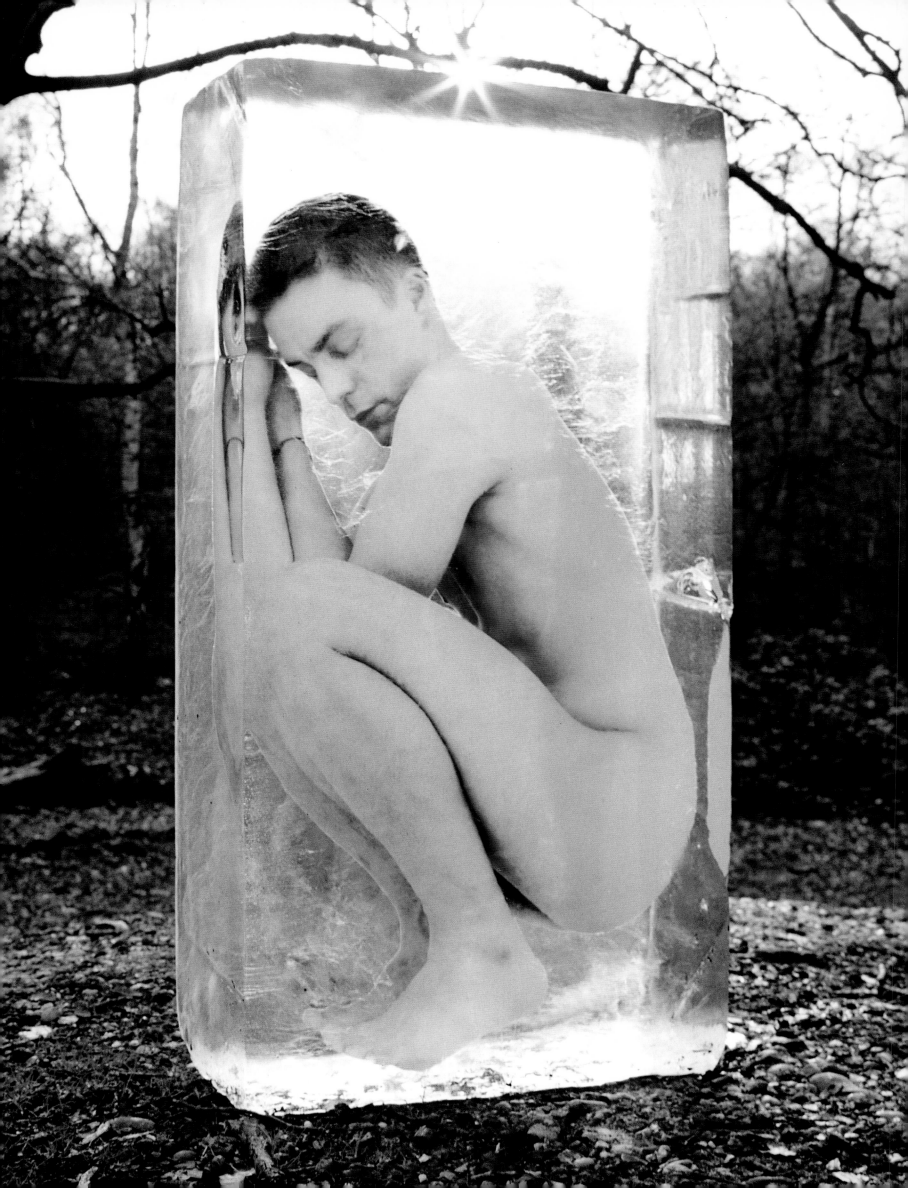

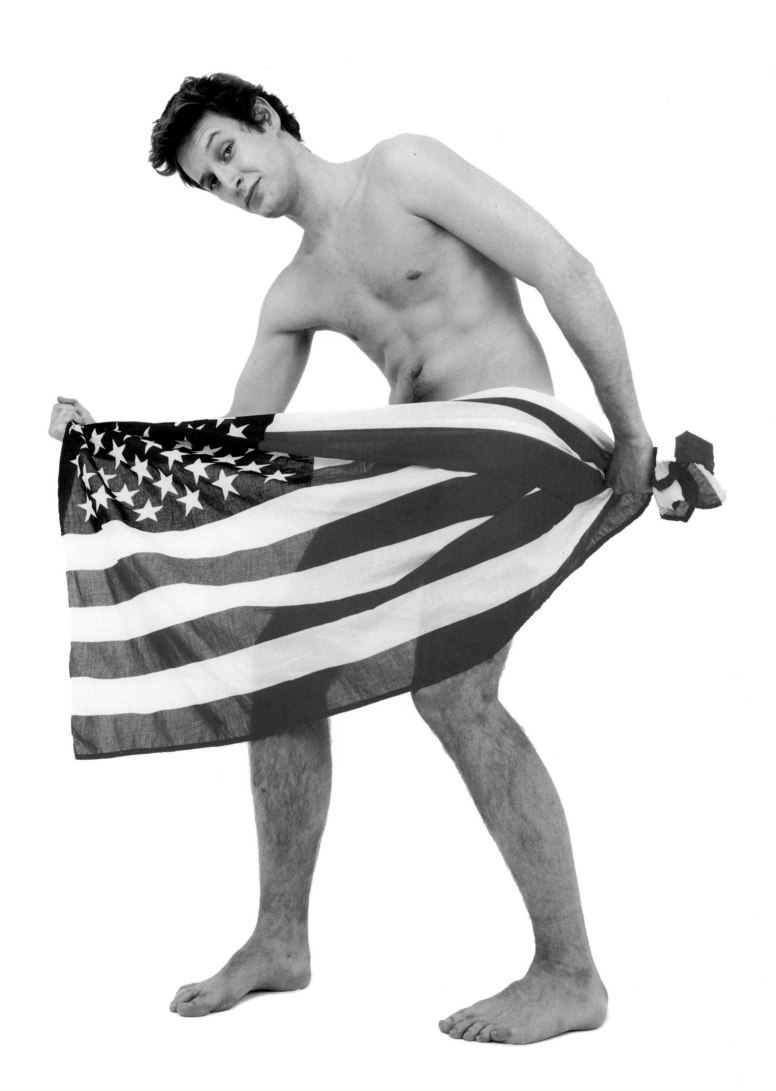

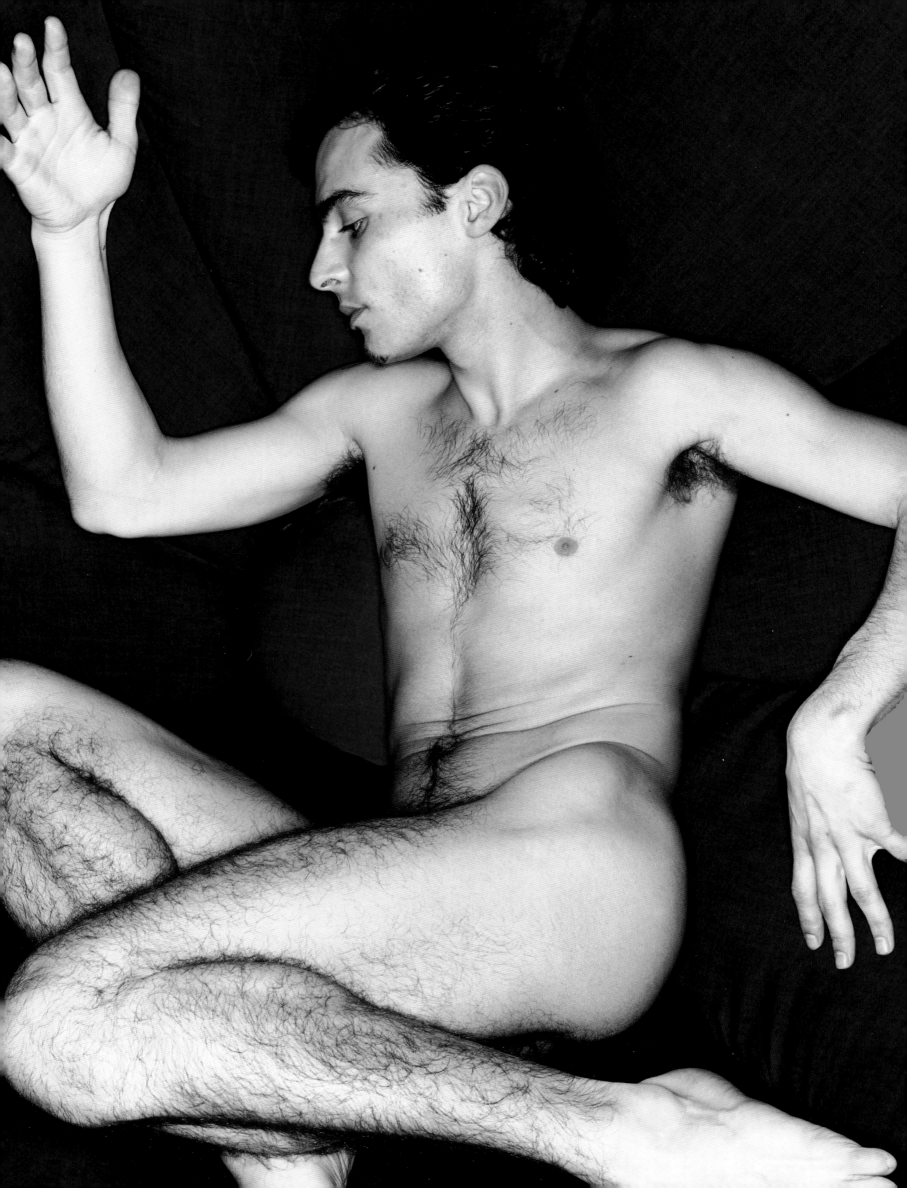

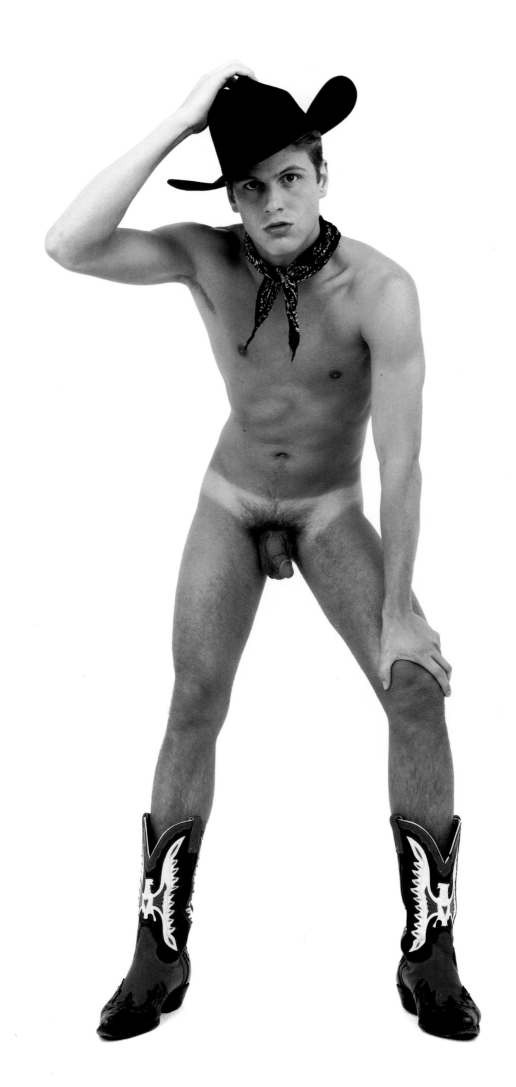

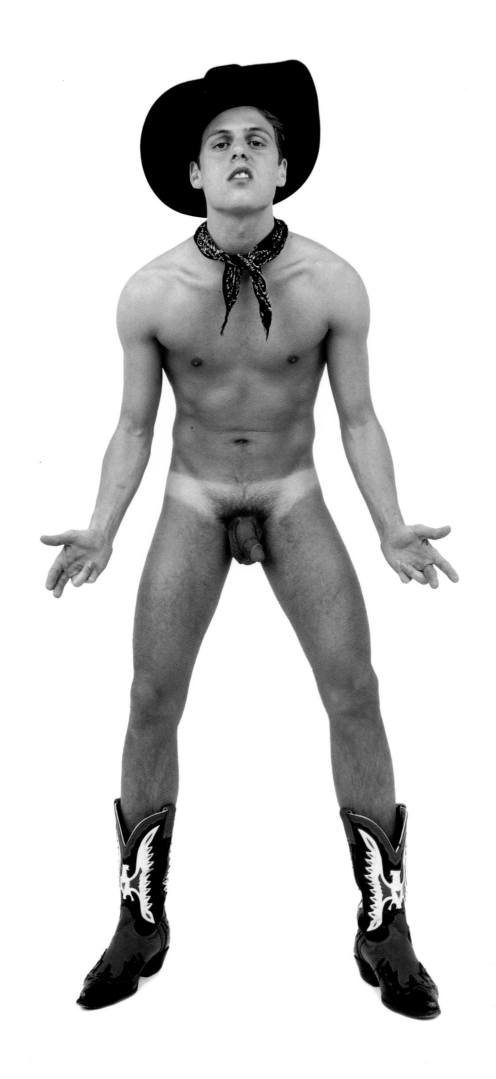

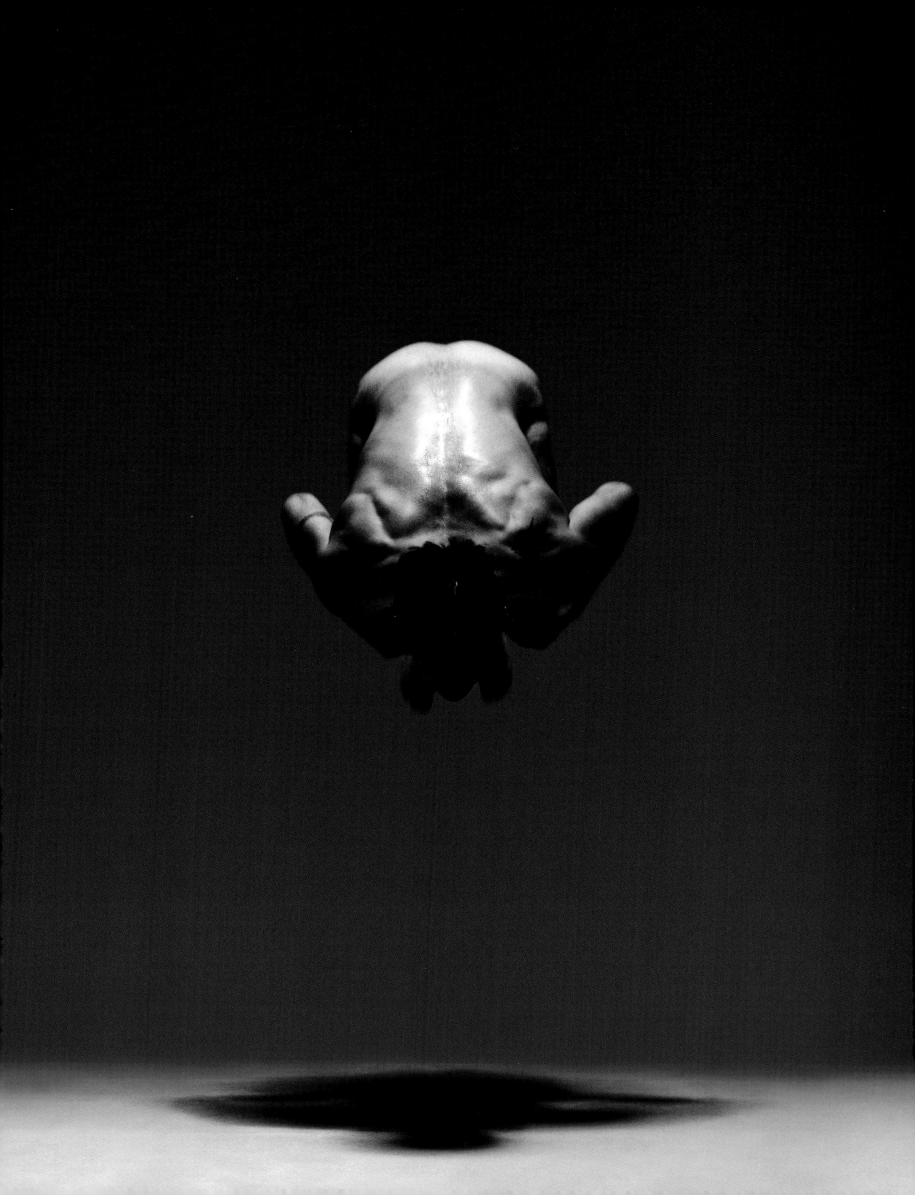

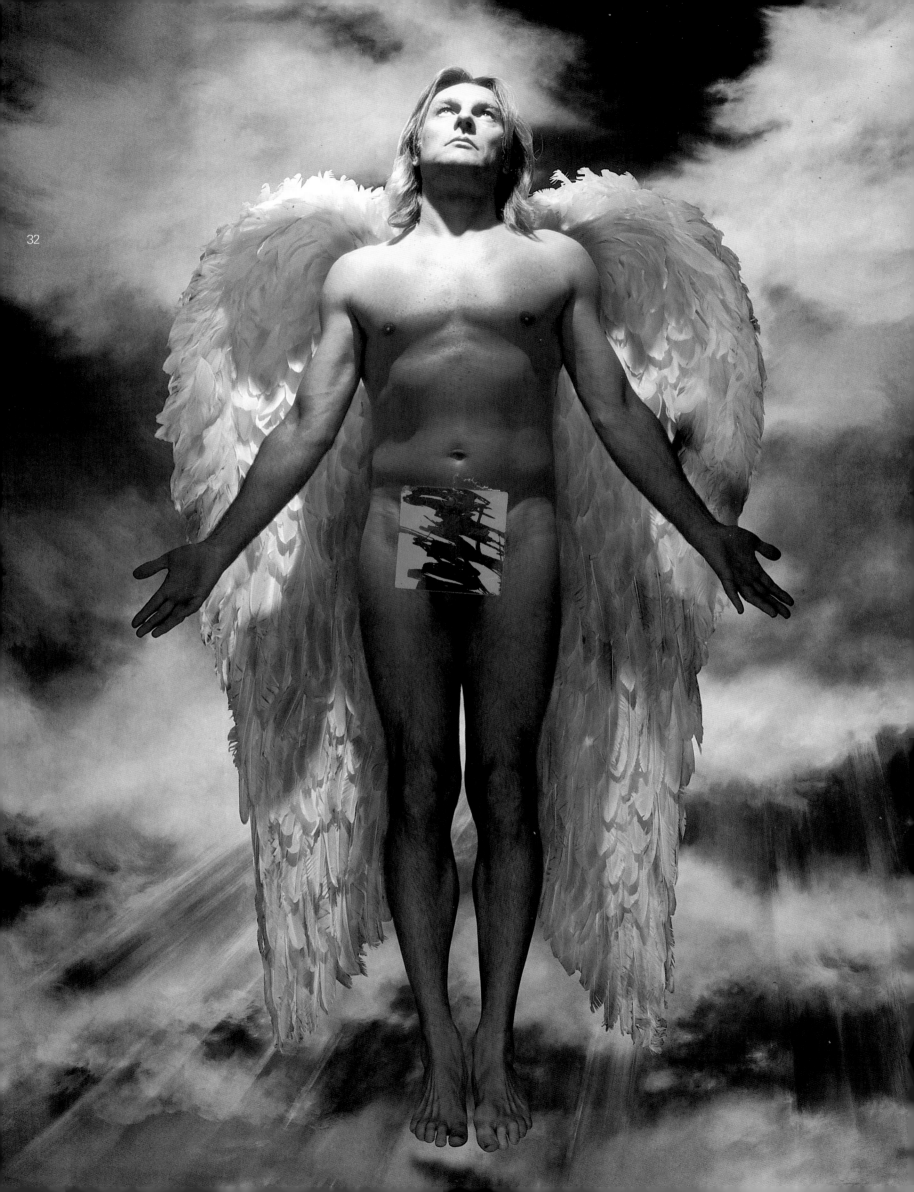

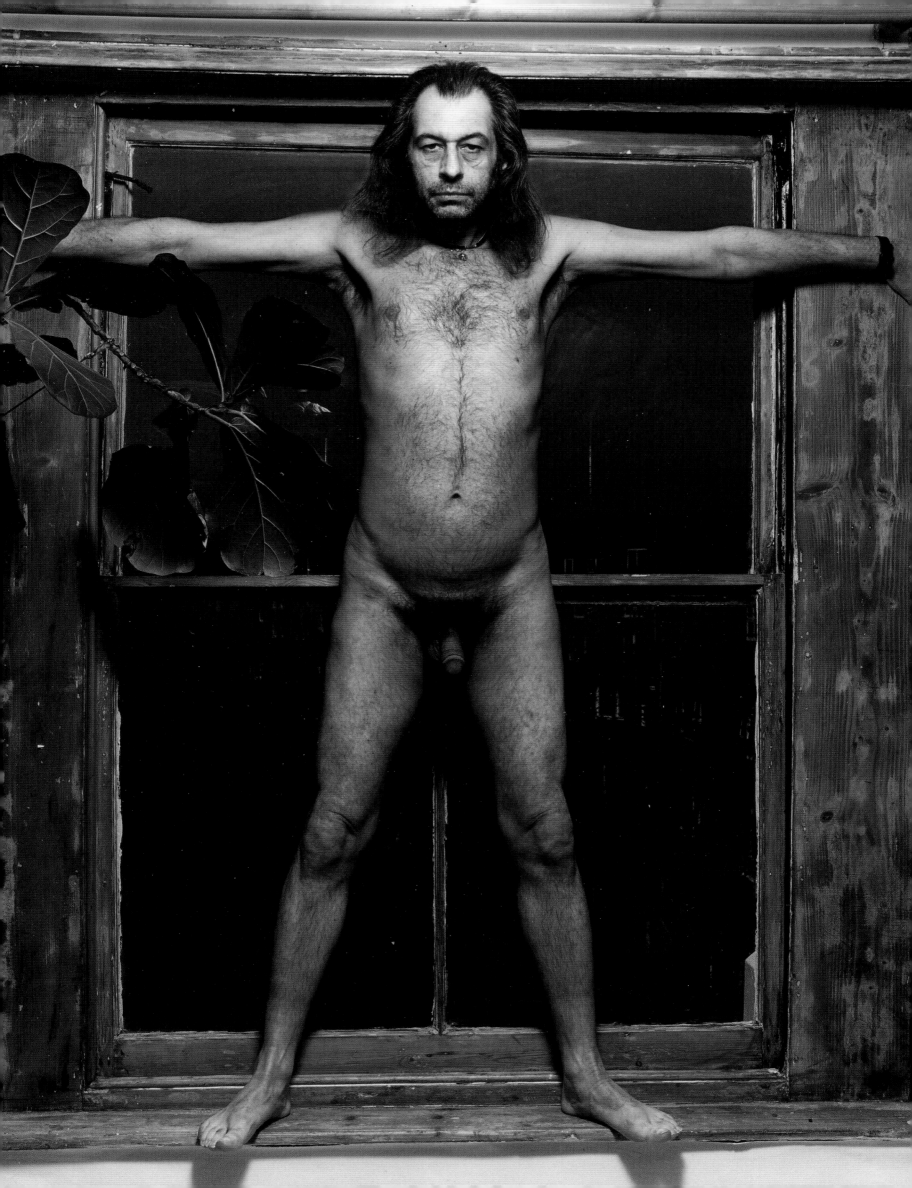

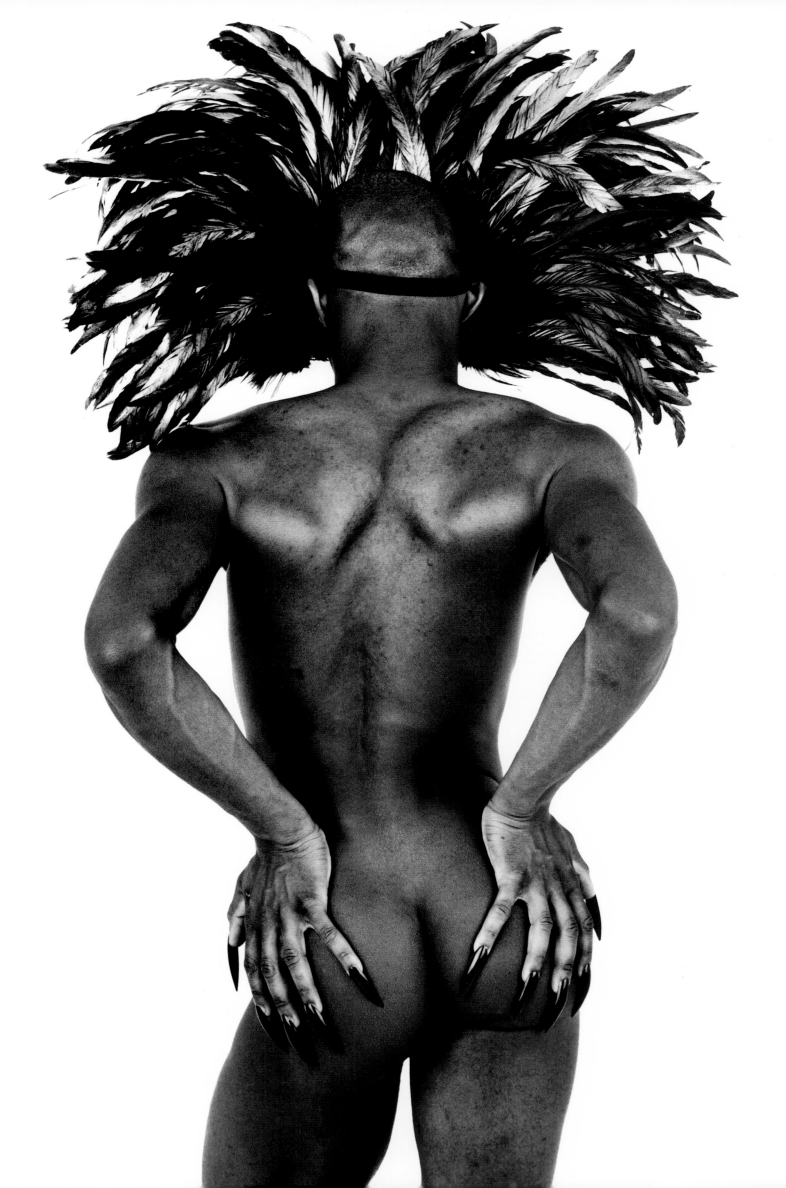

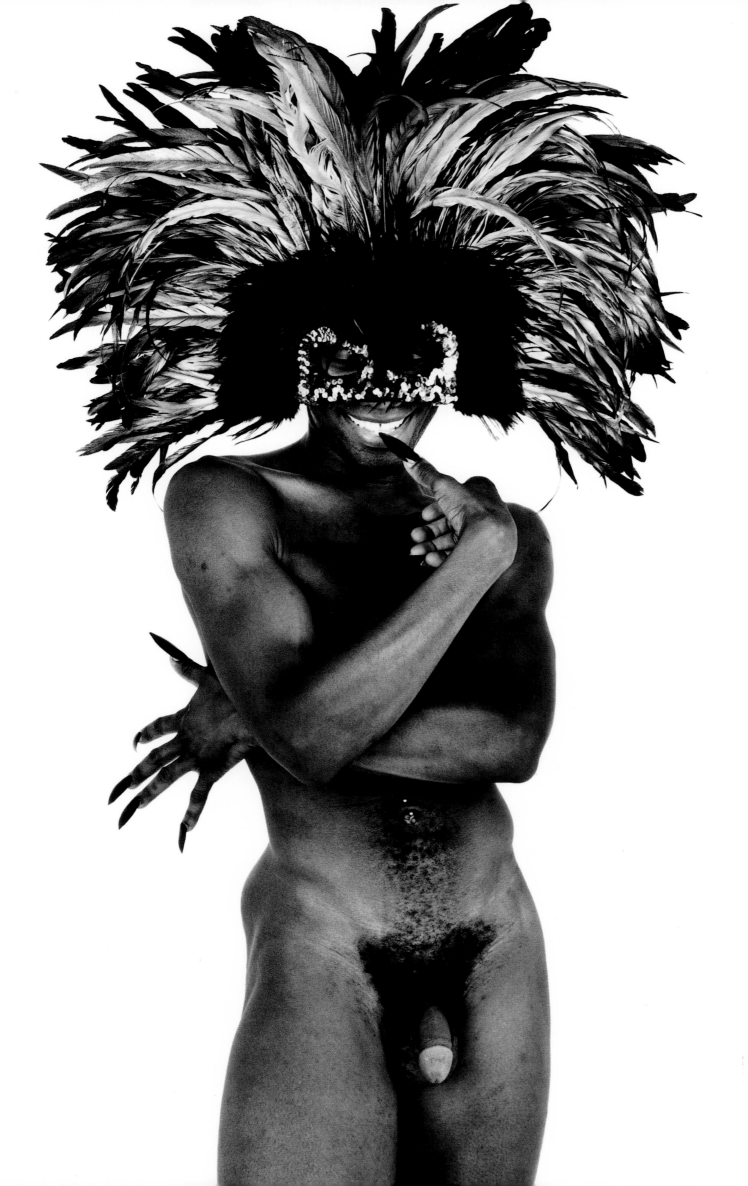

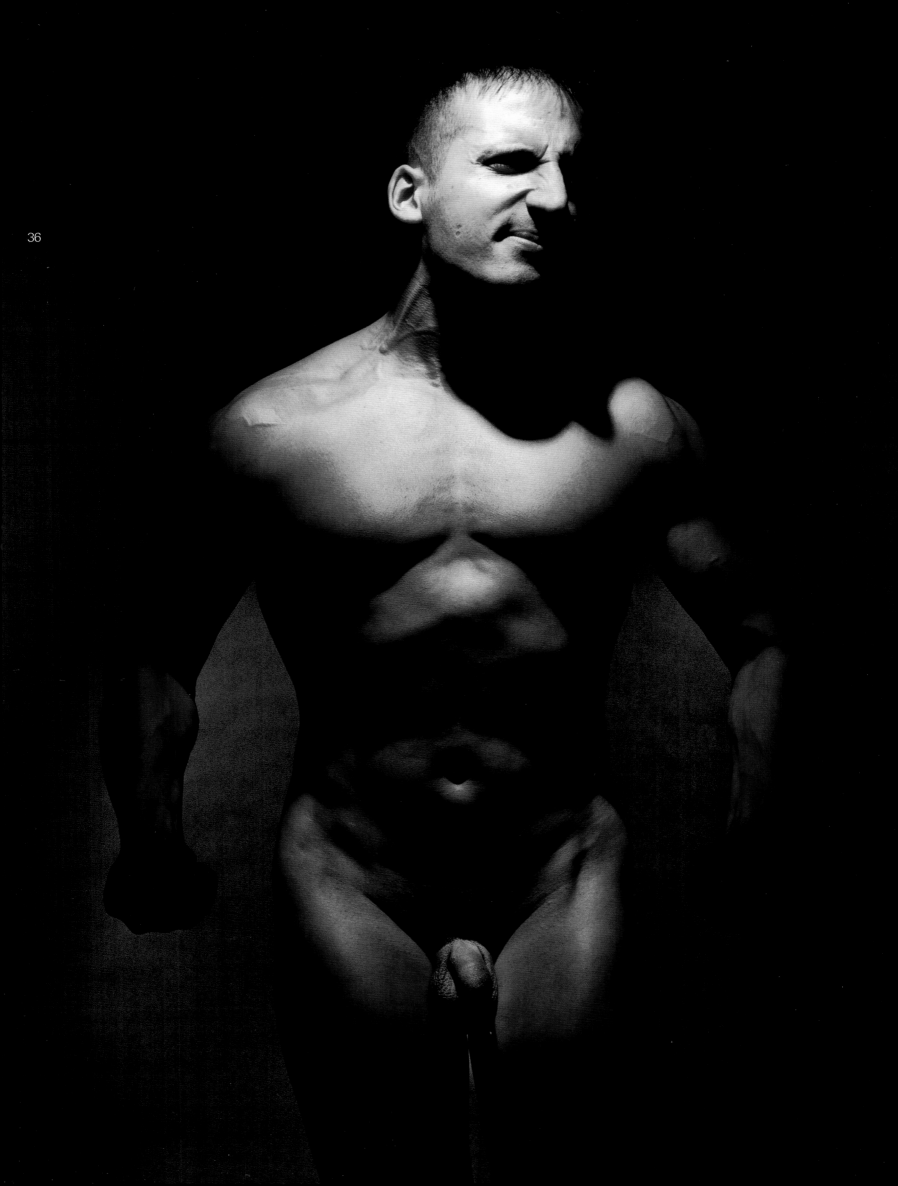

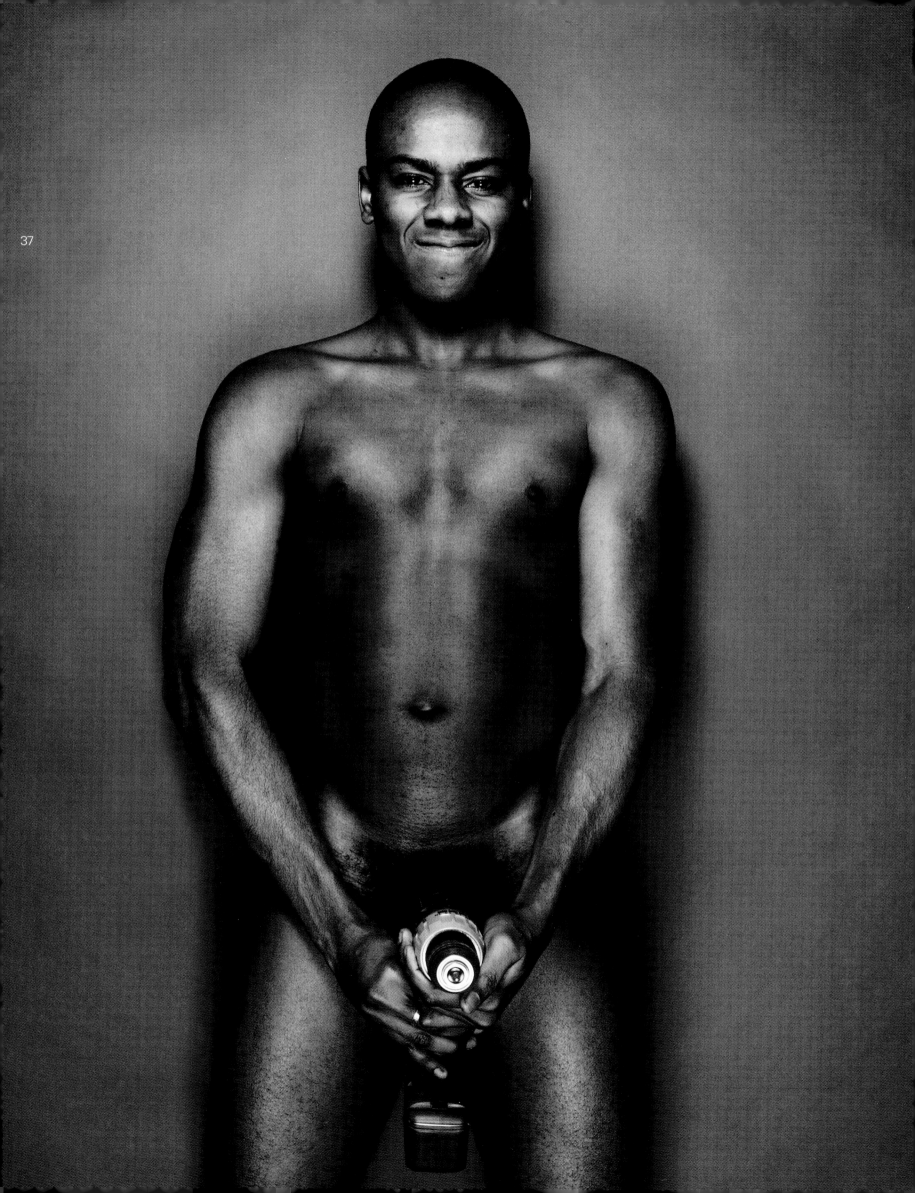

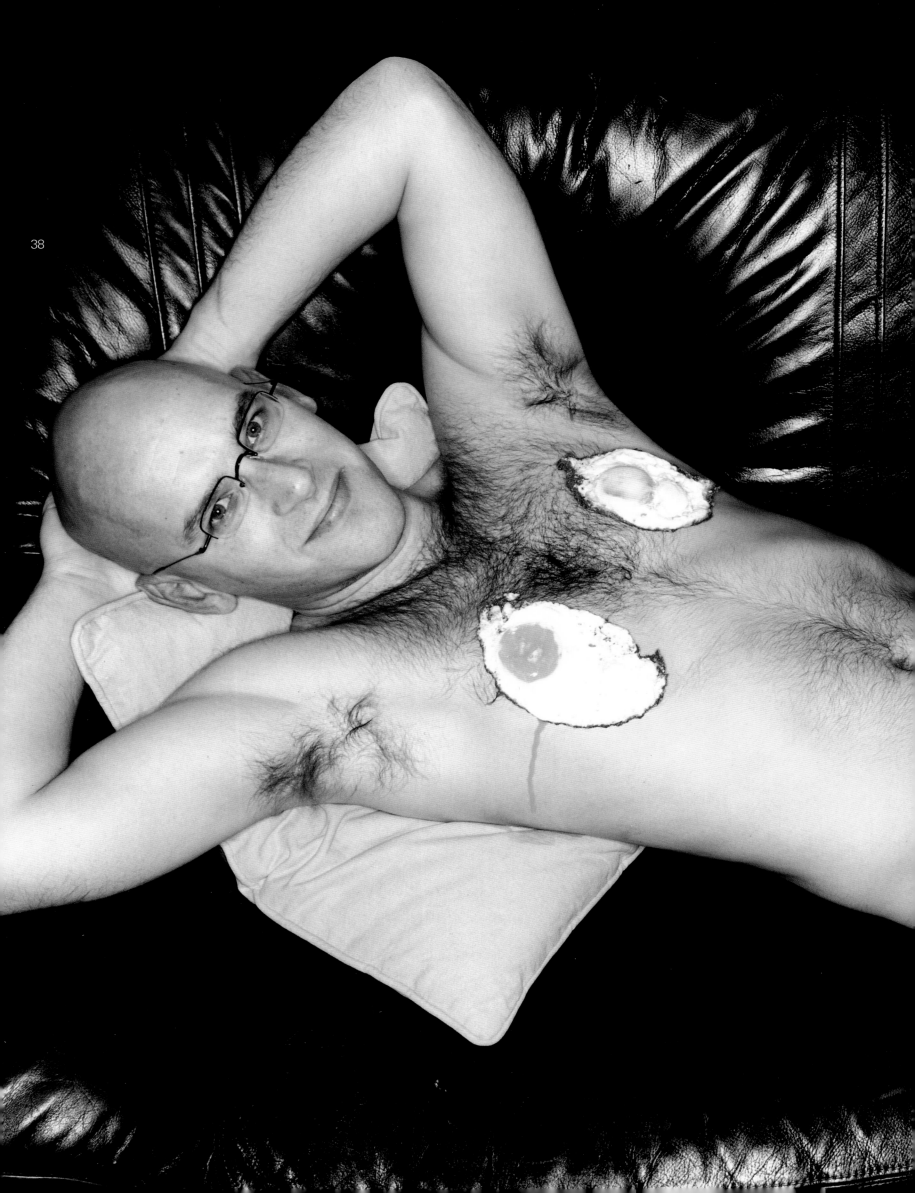

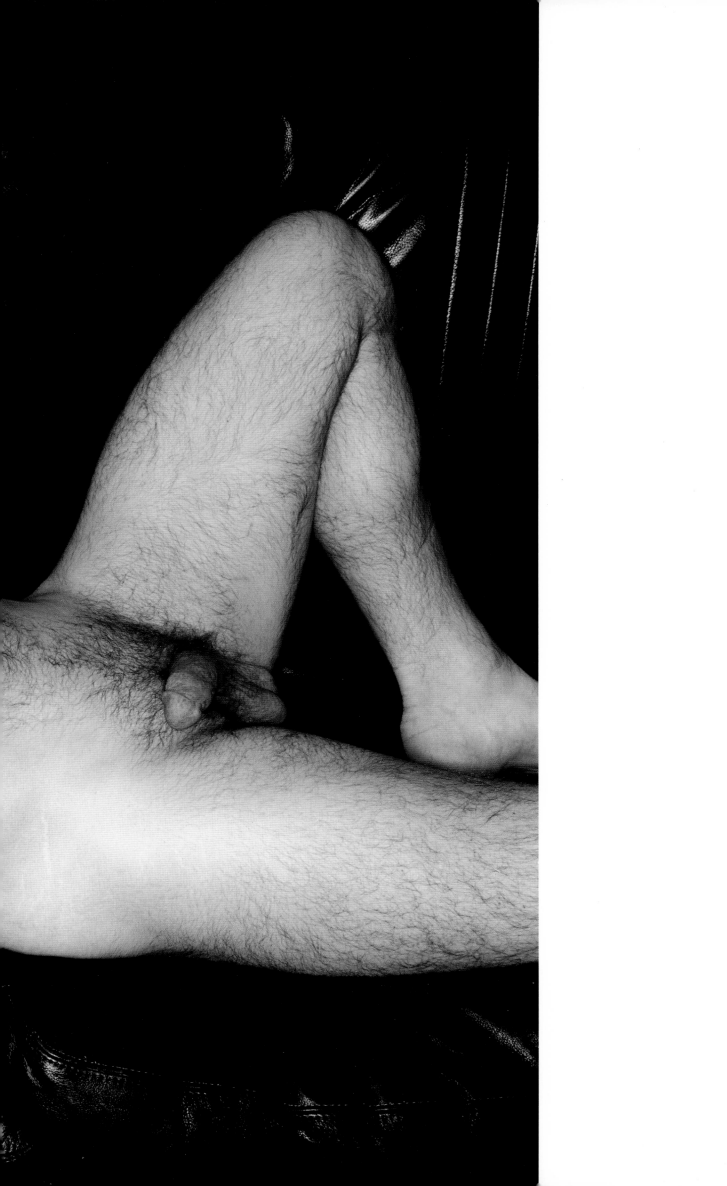

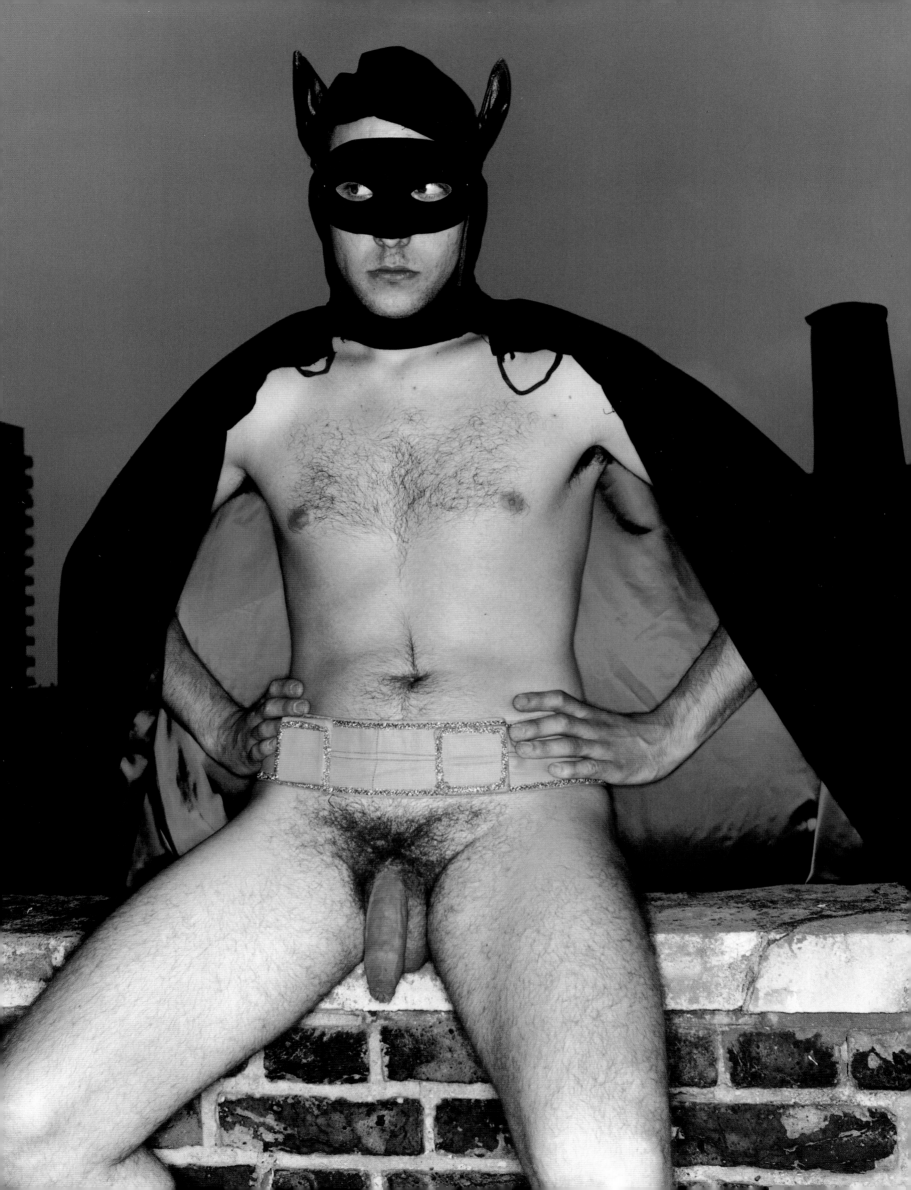

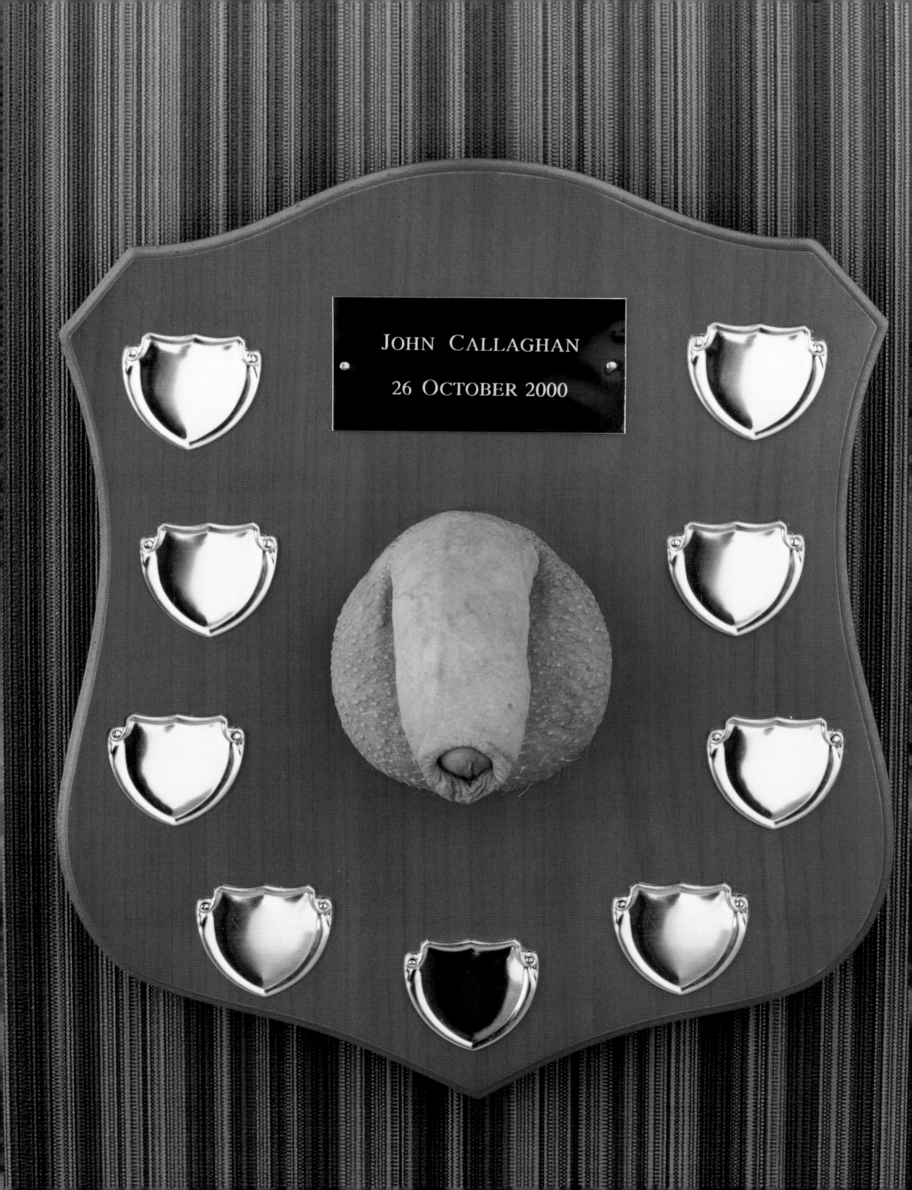

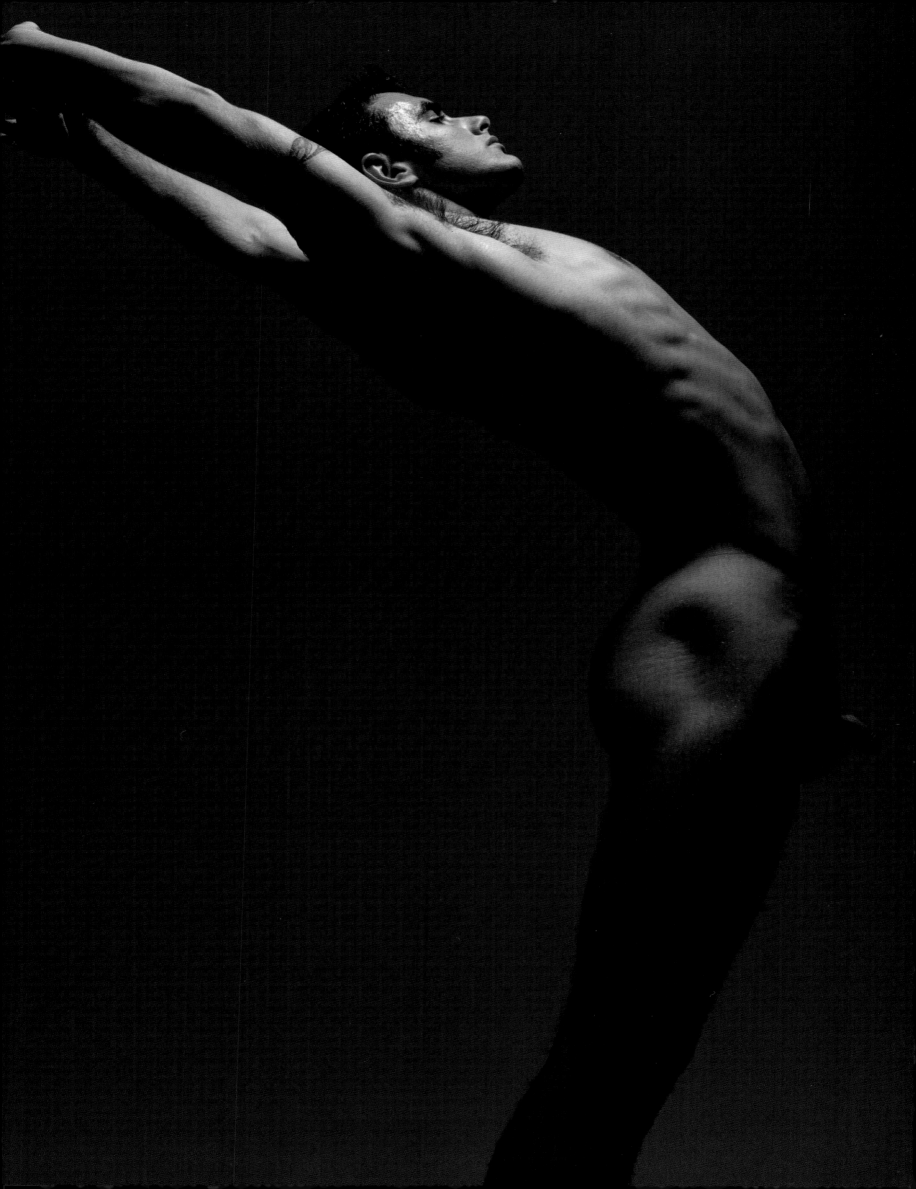

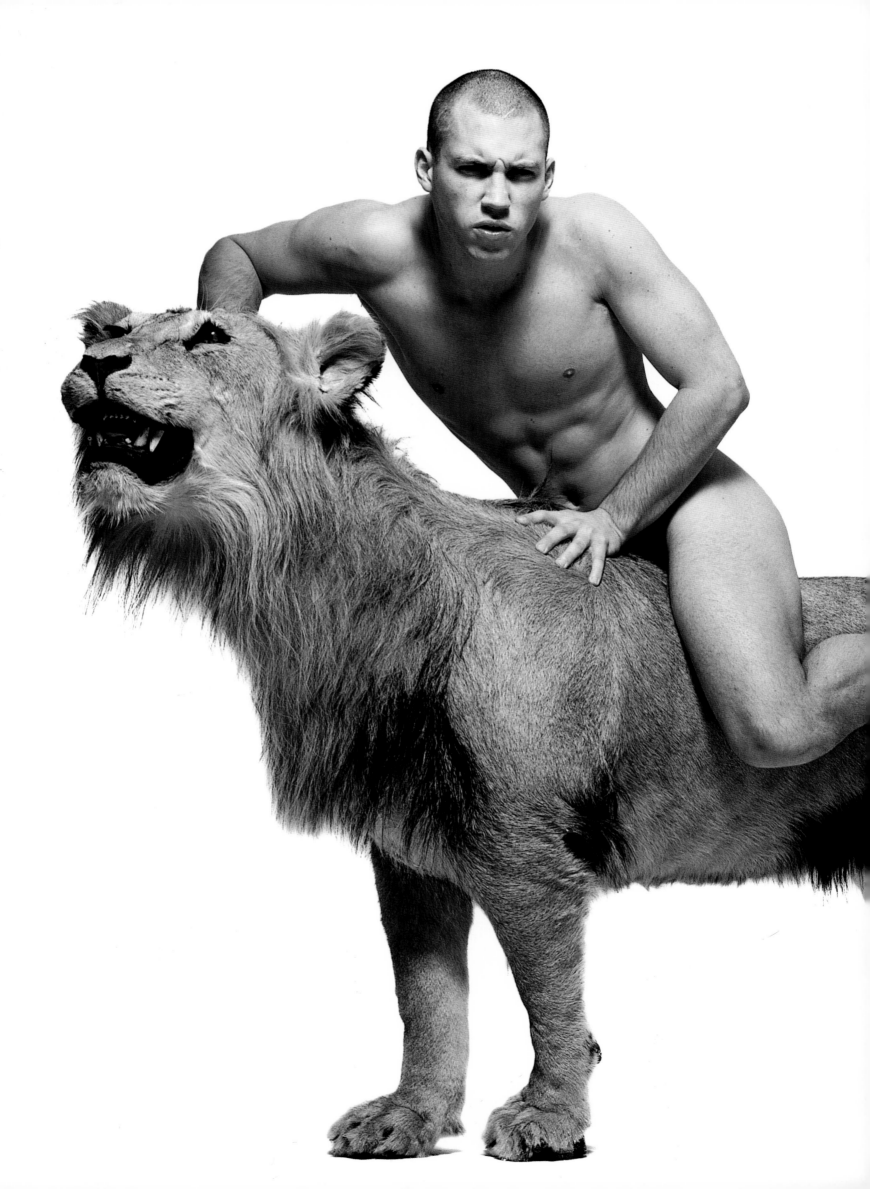

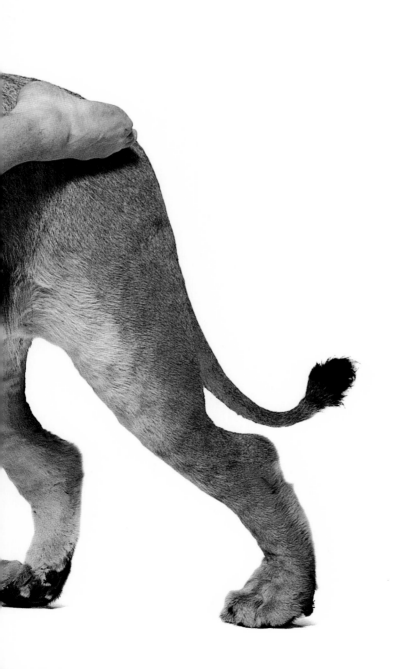

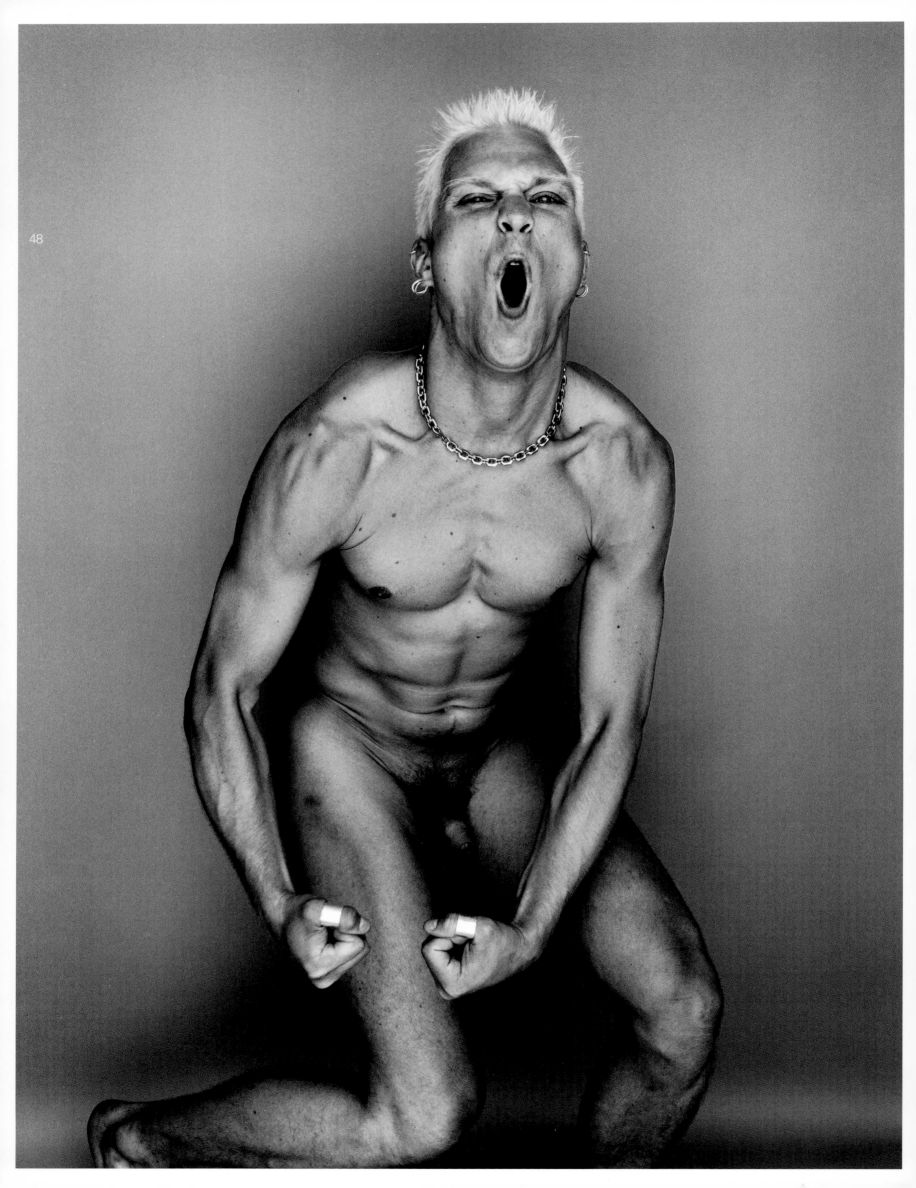

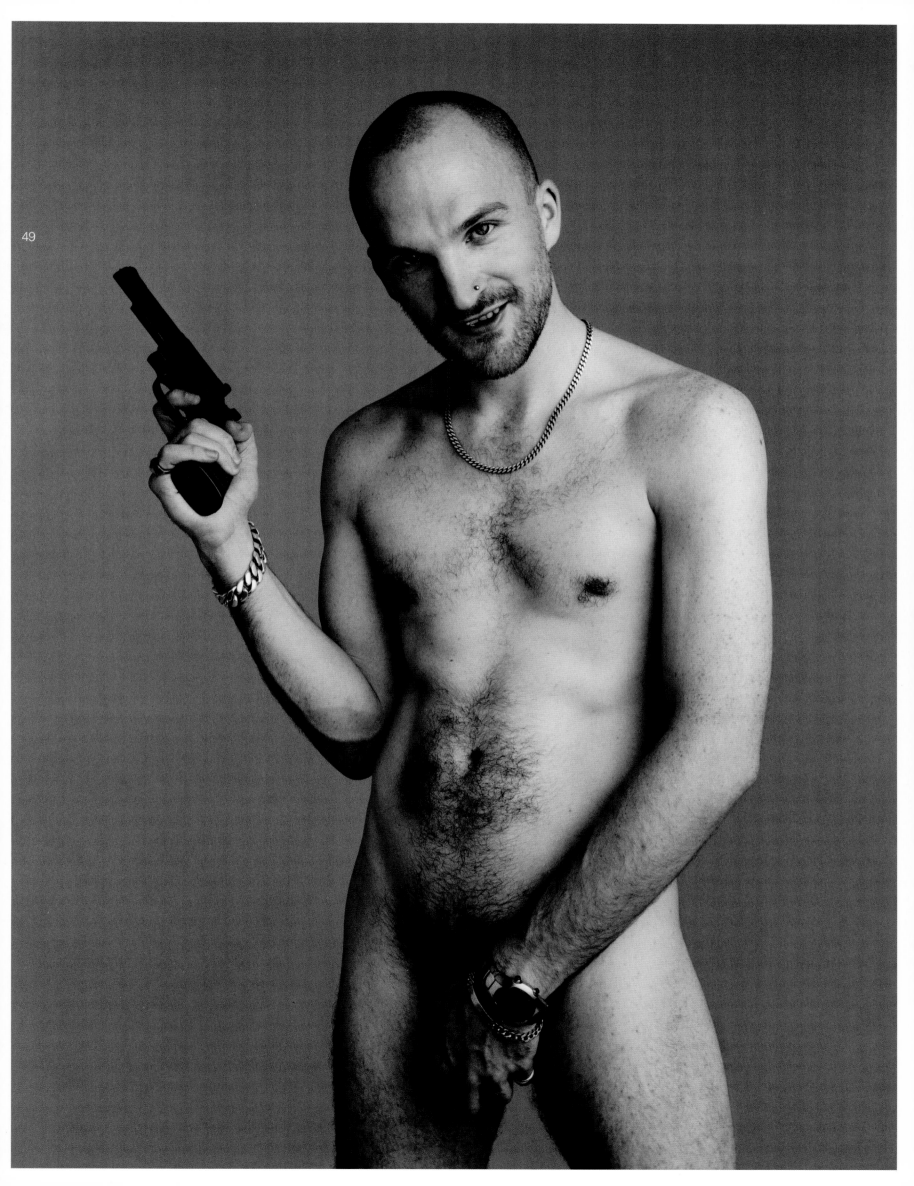

49

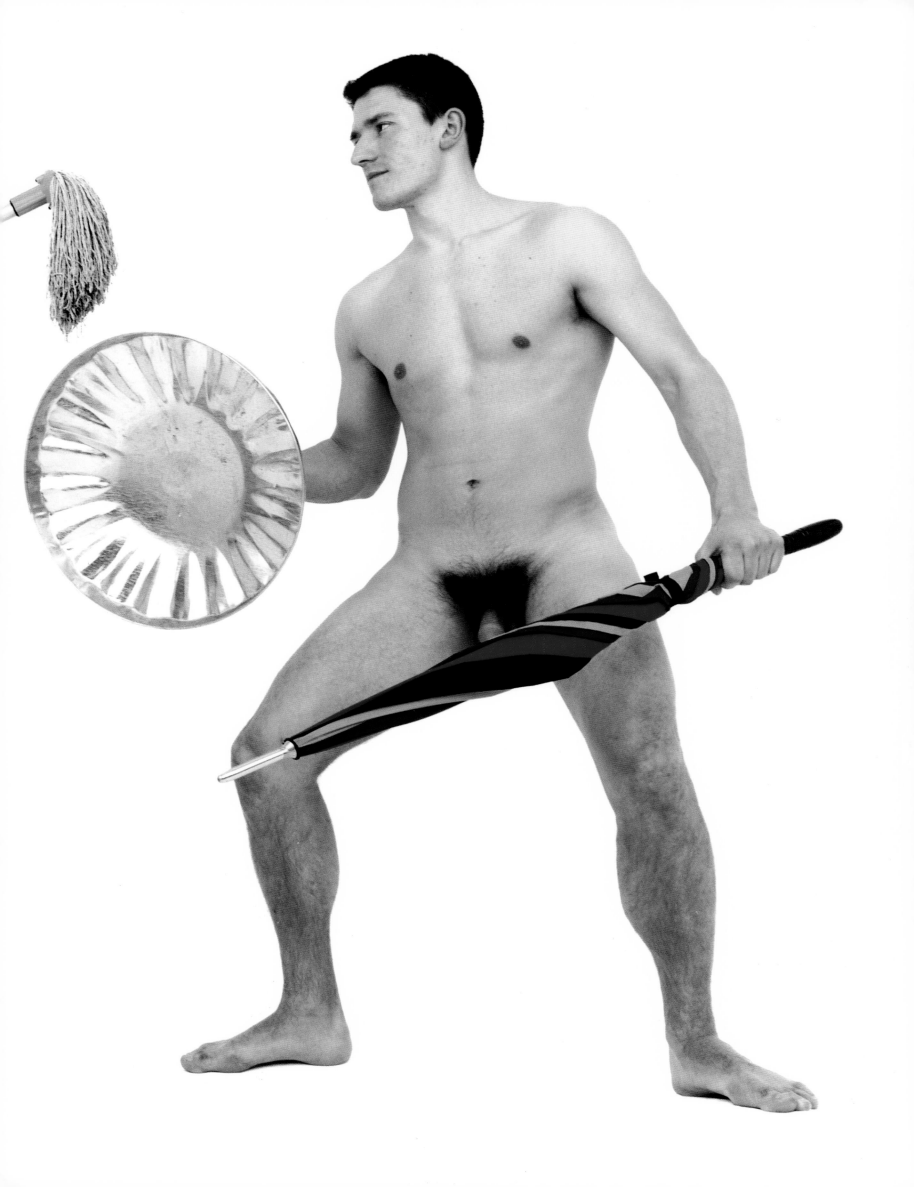

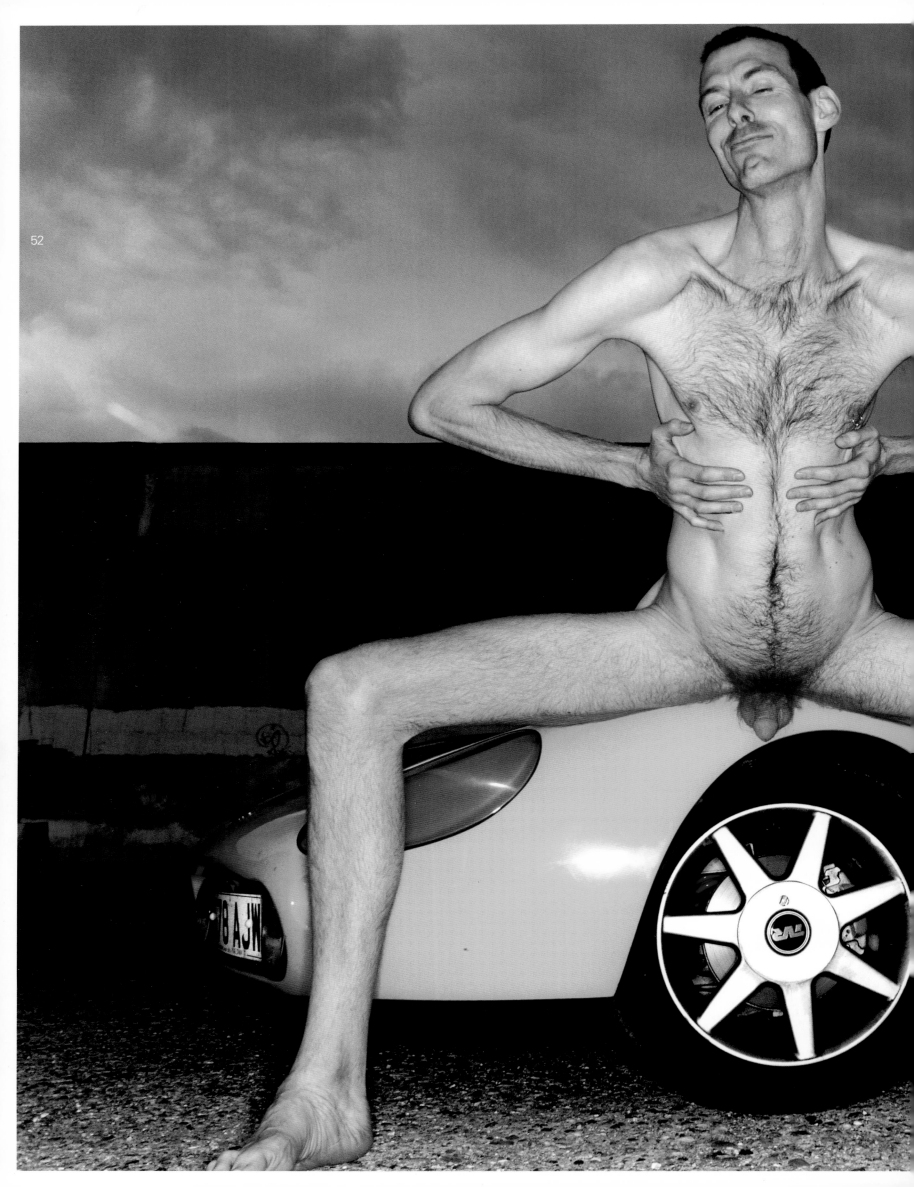

52

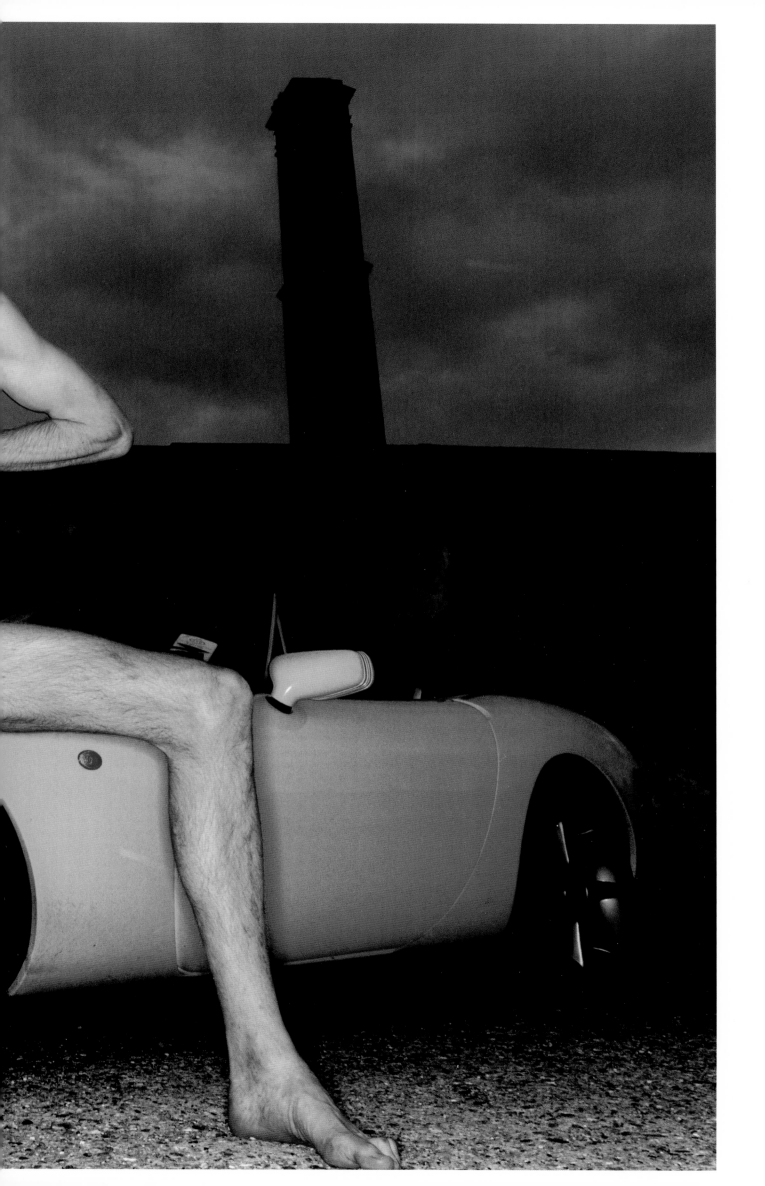

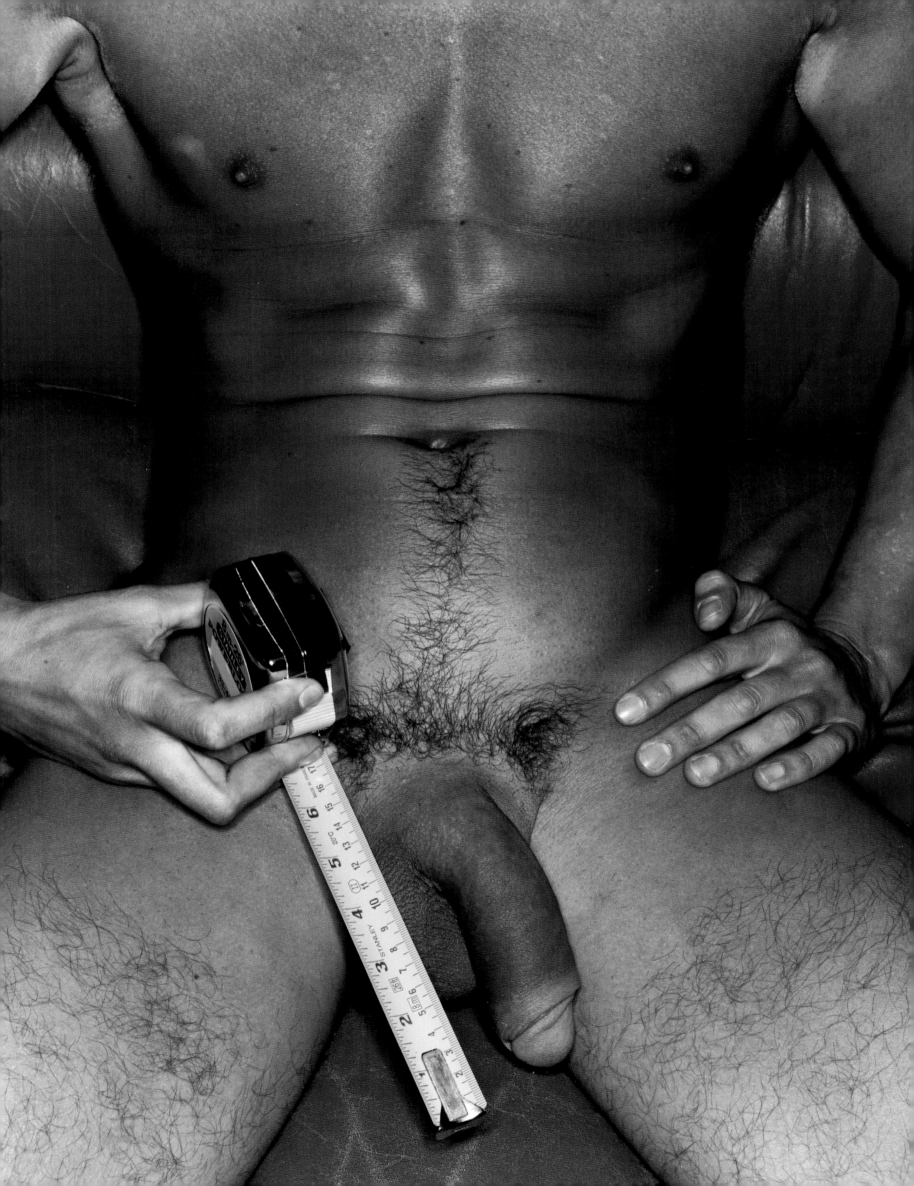

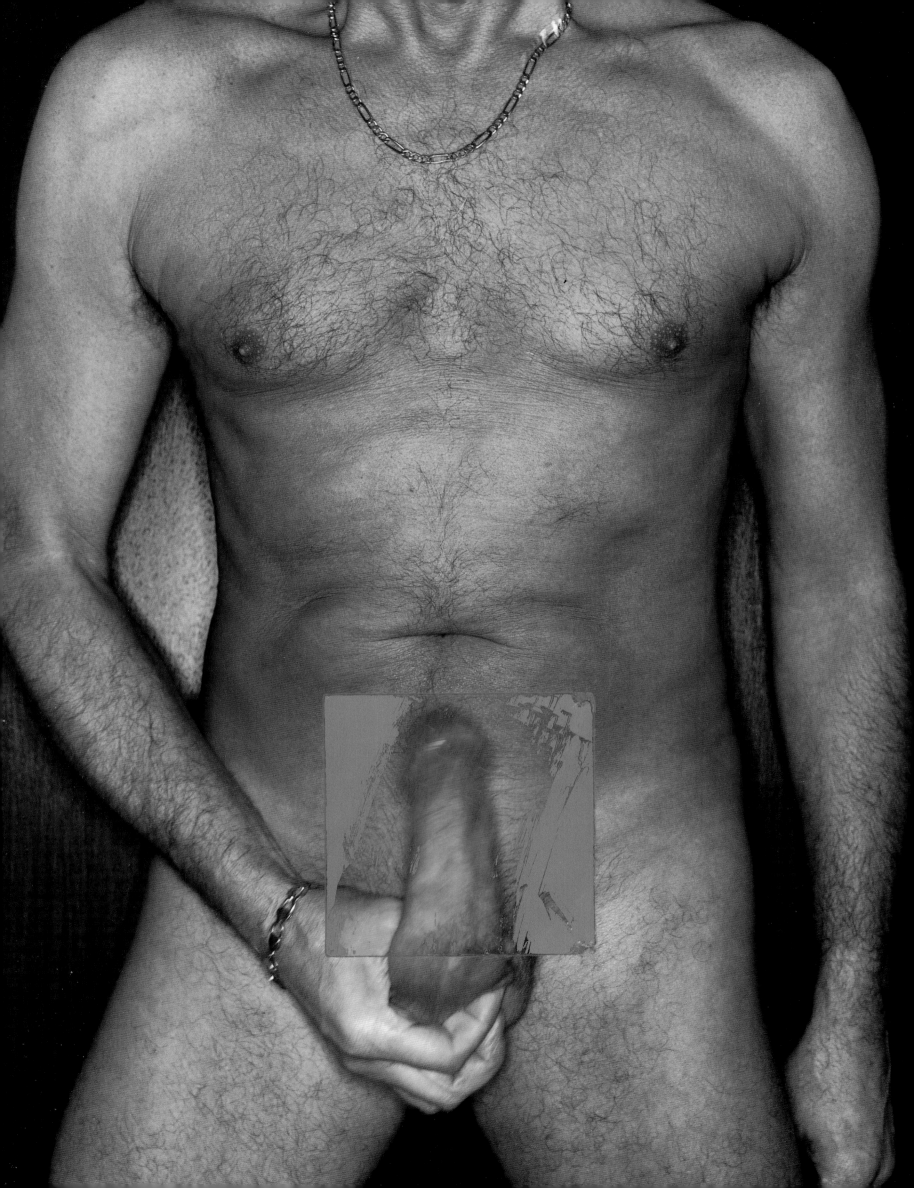

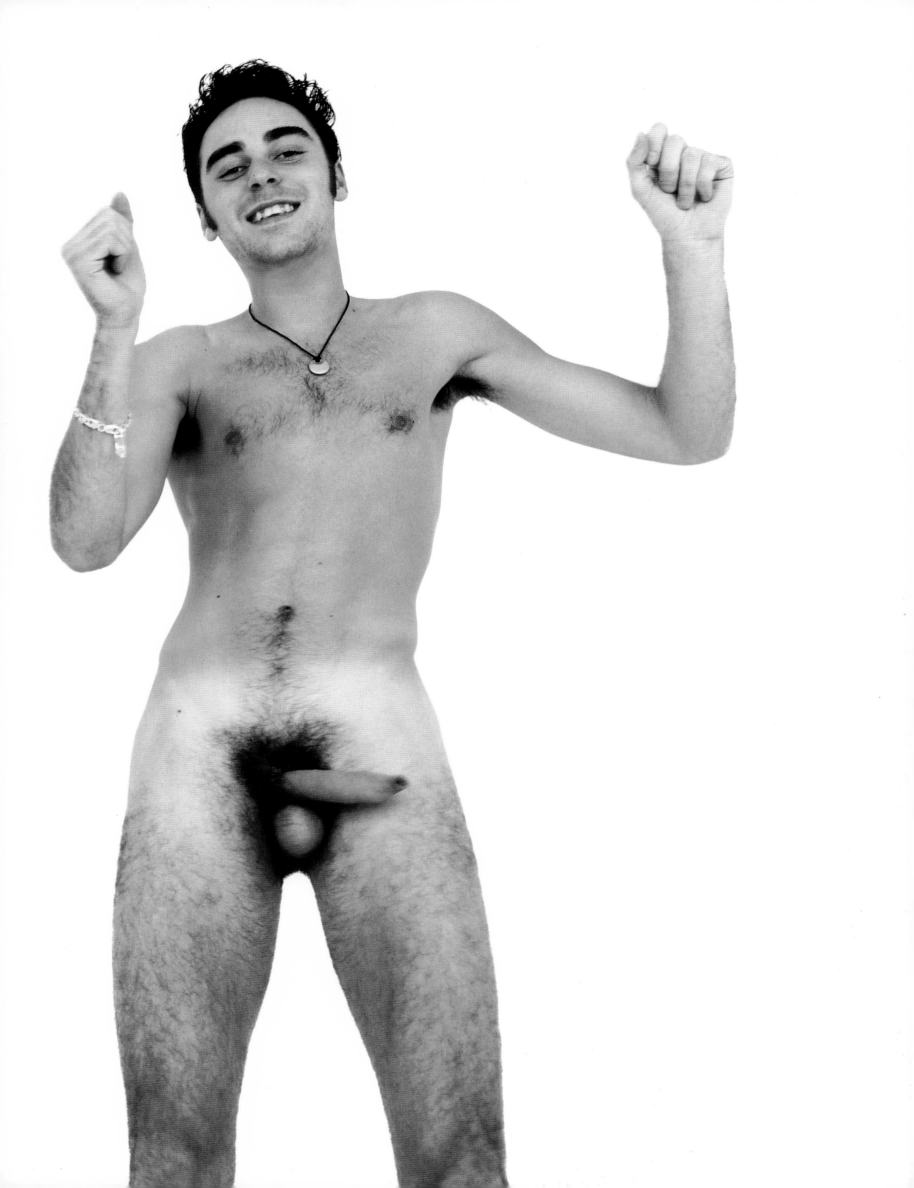

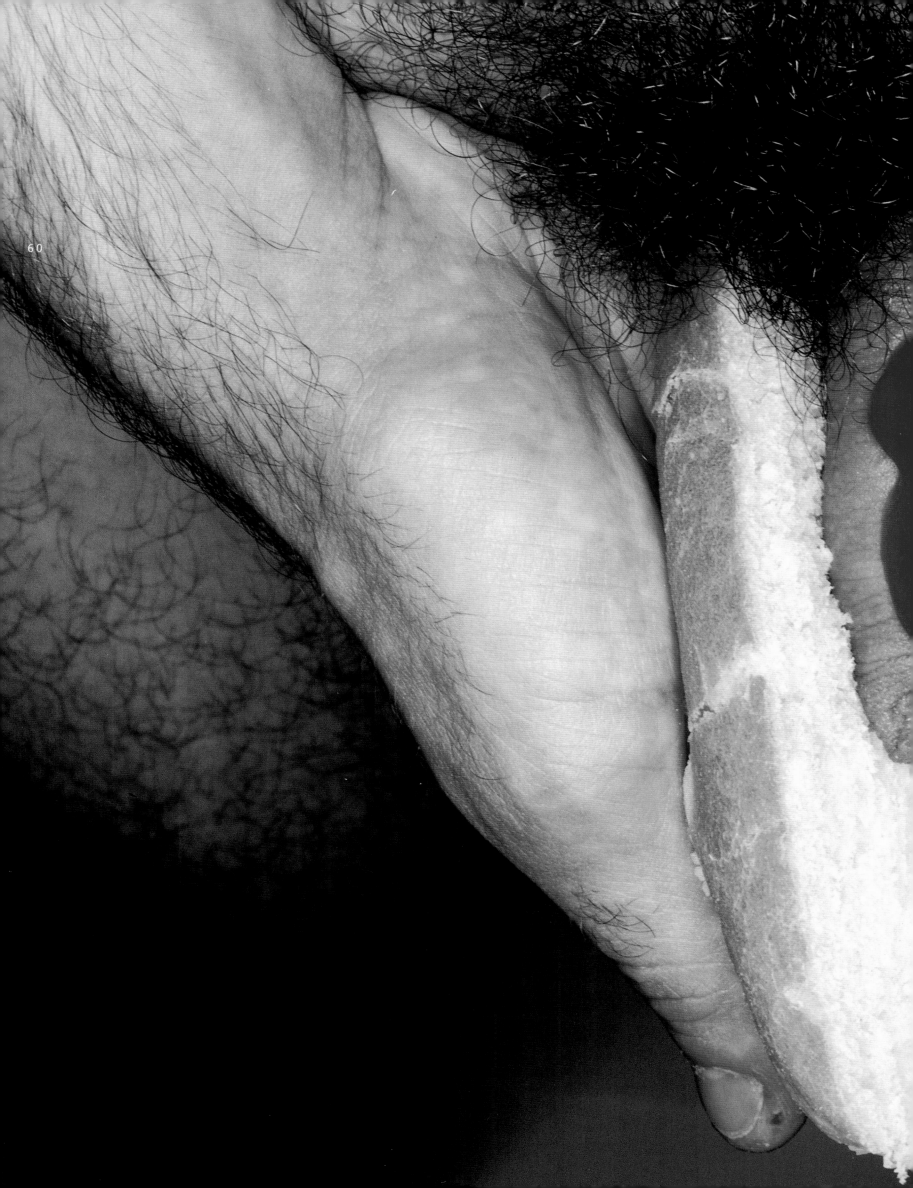

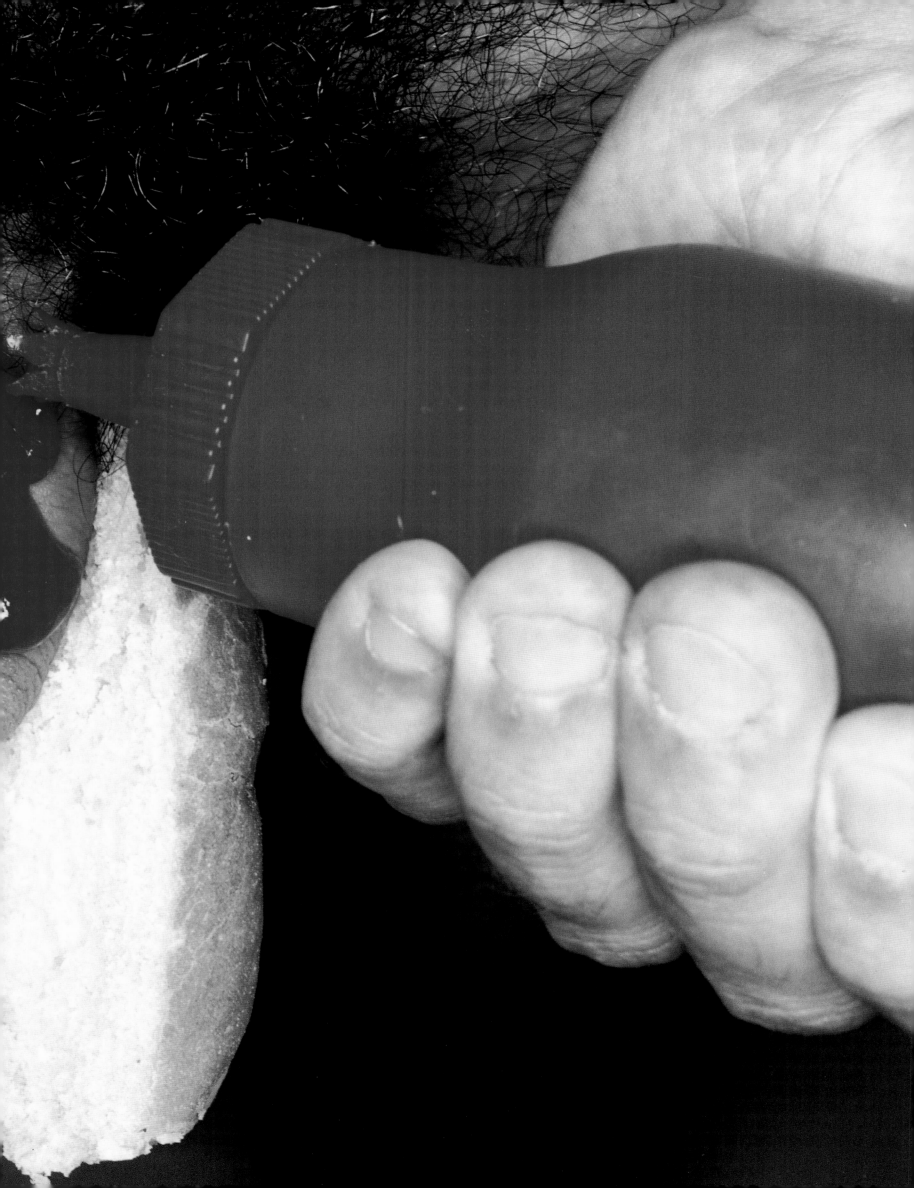

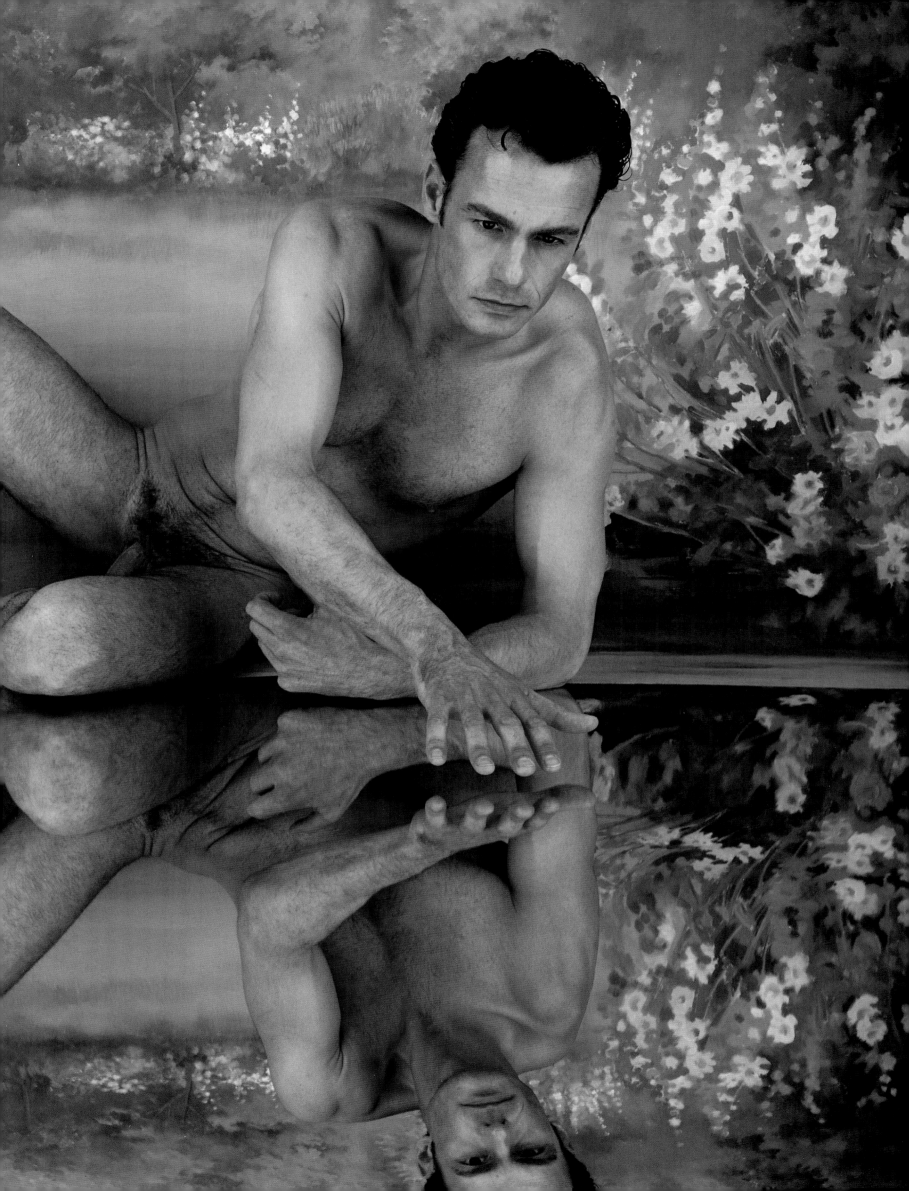

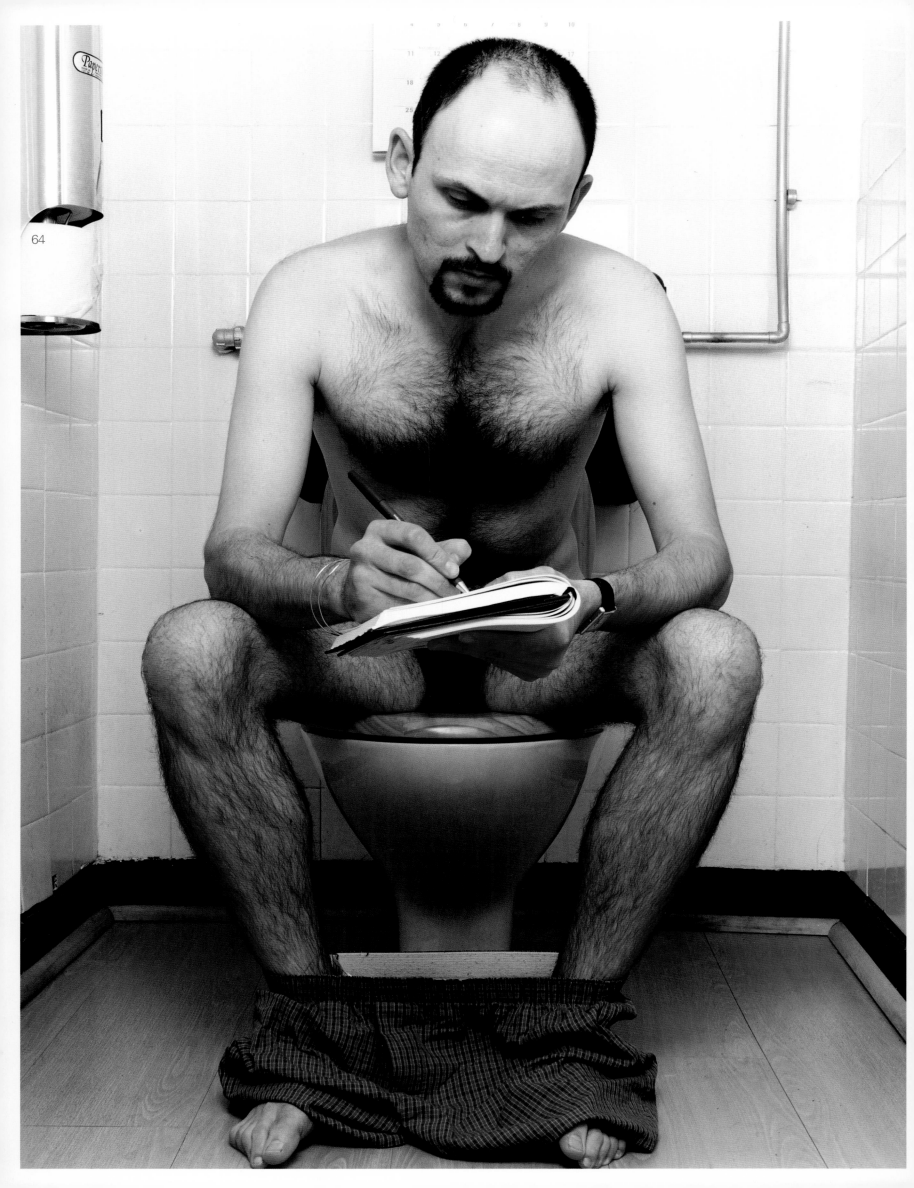

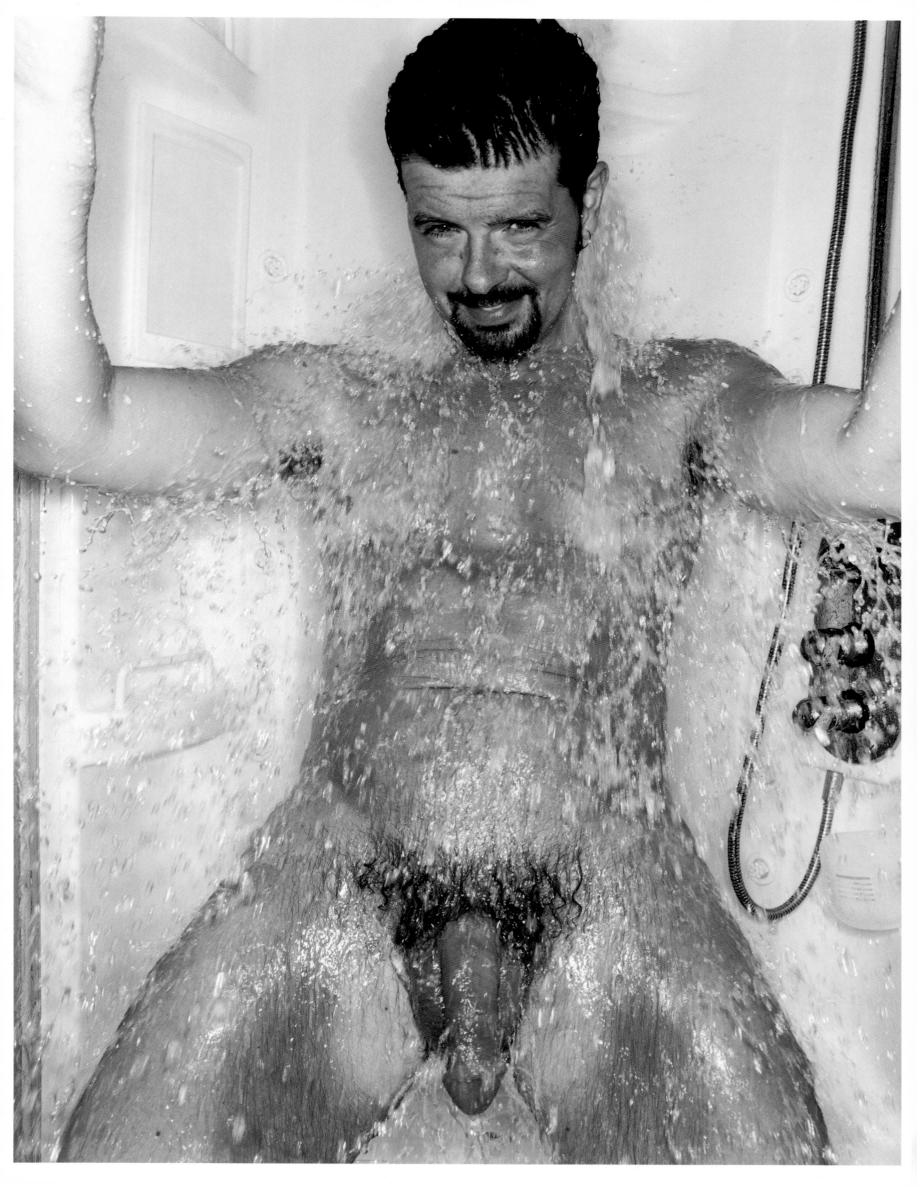

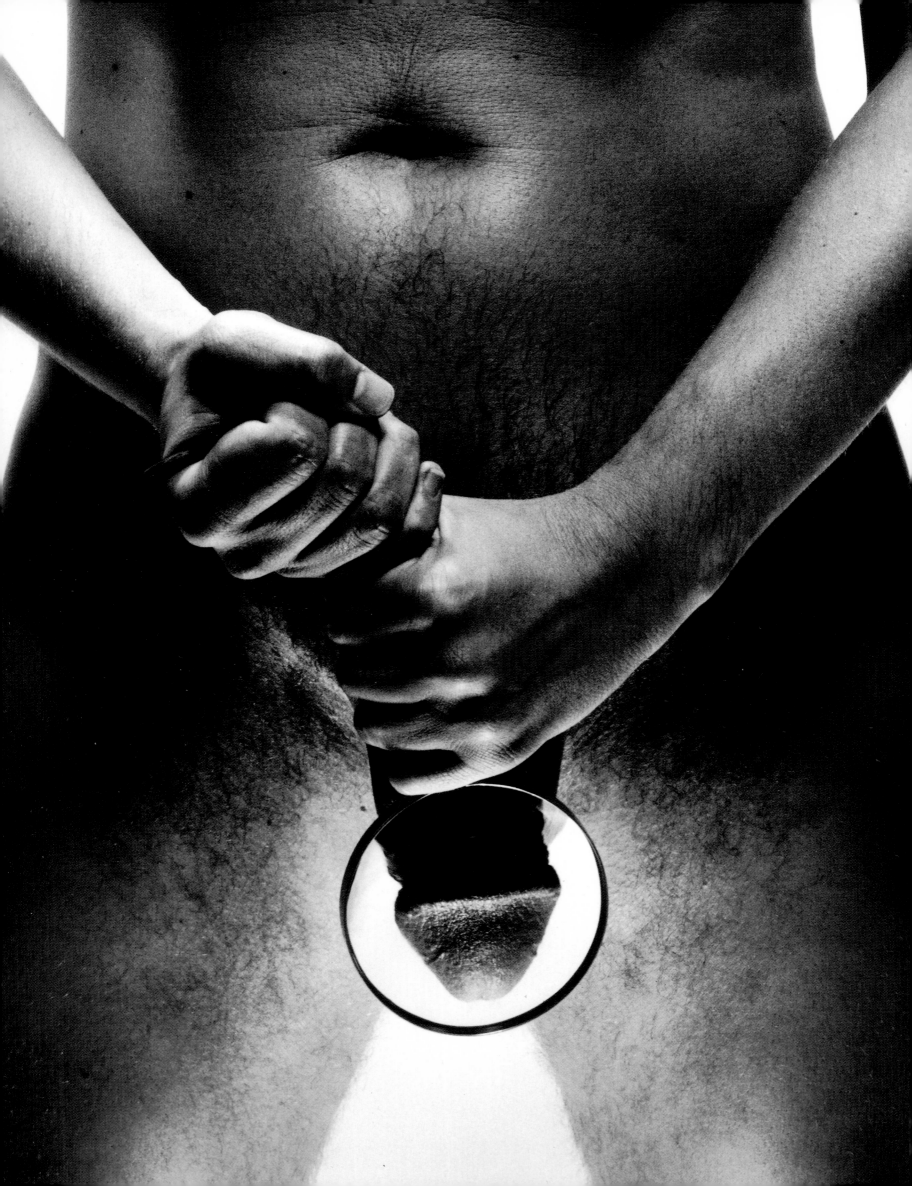

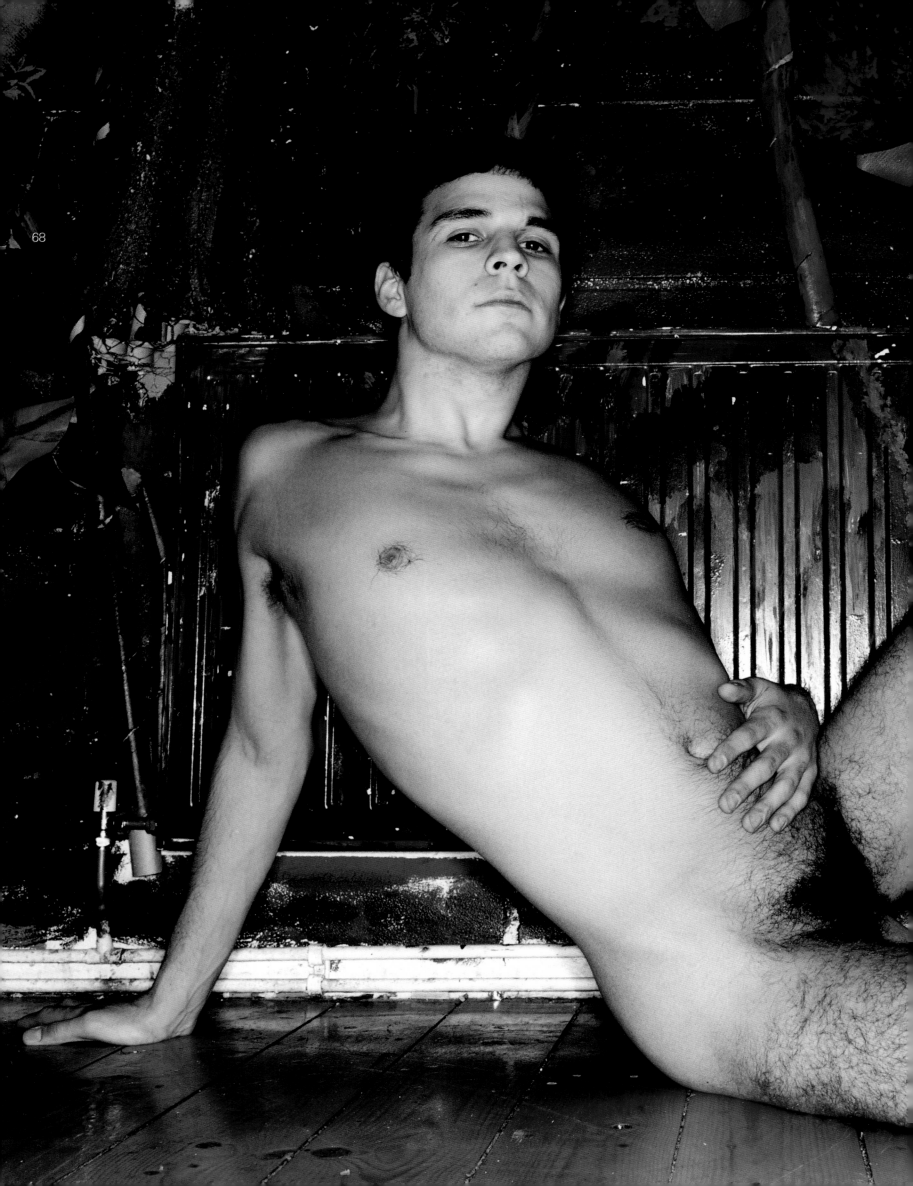

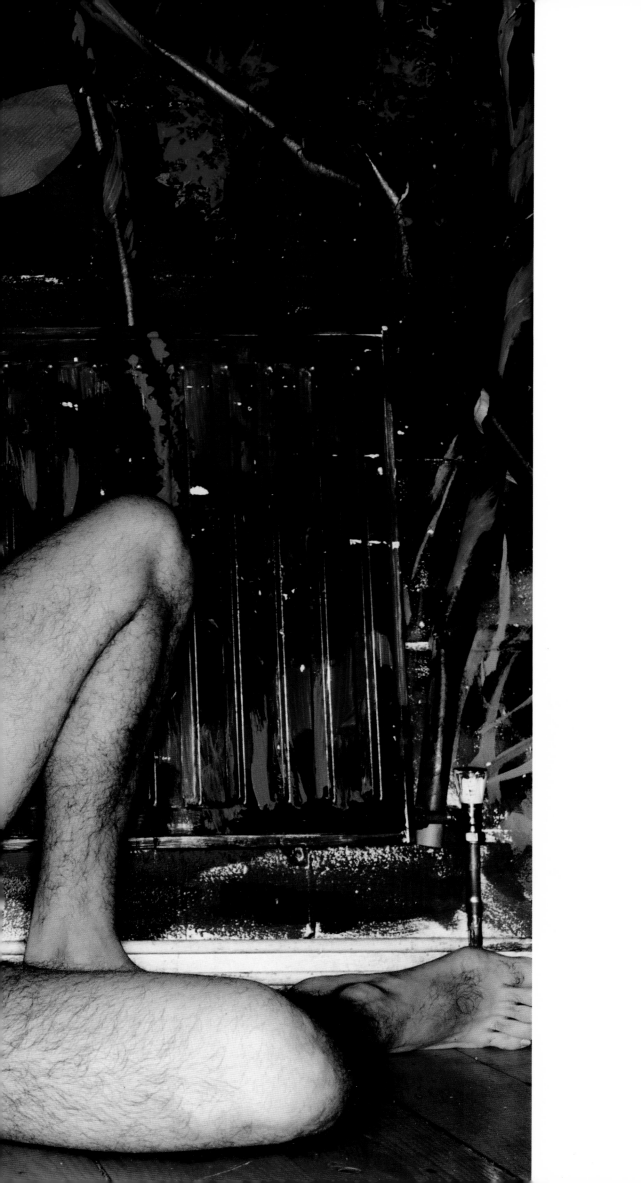

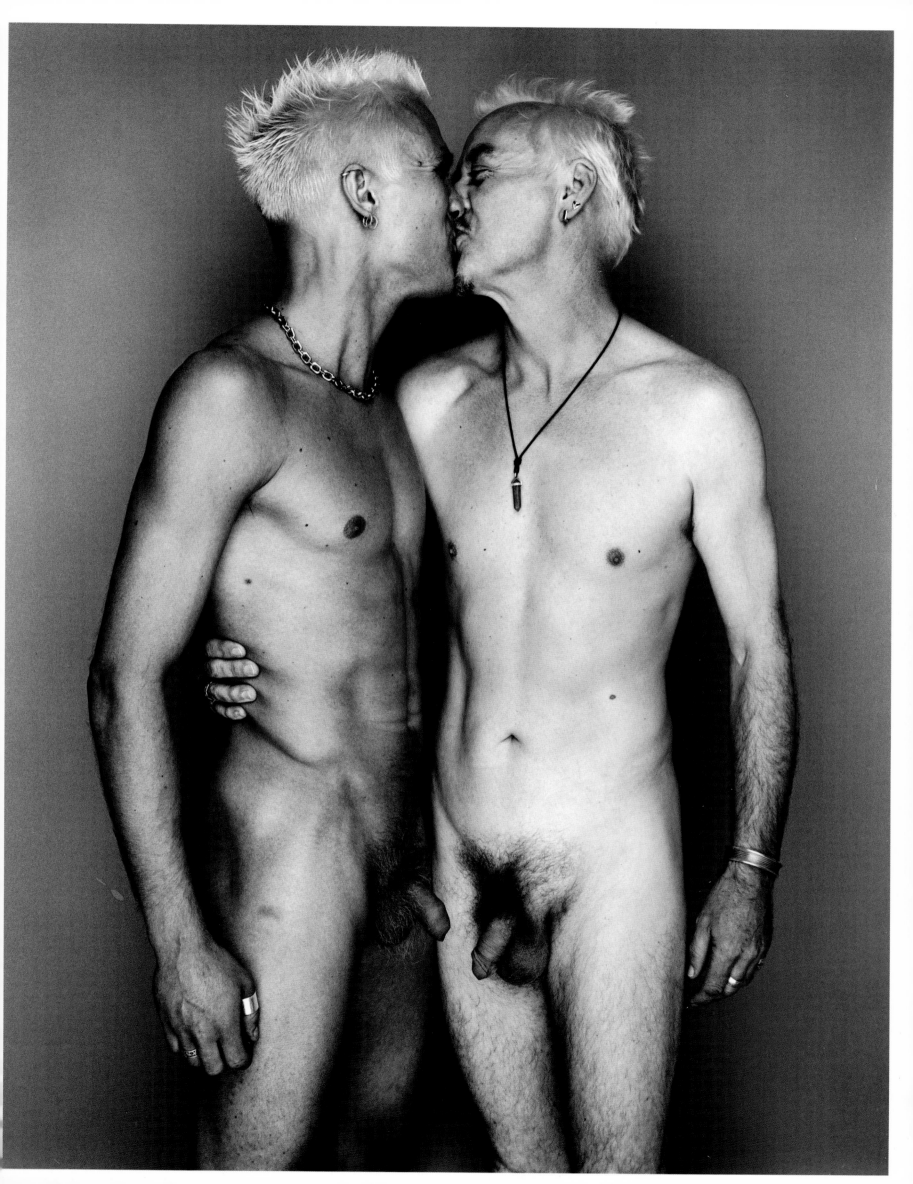

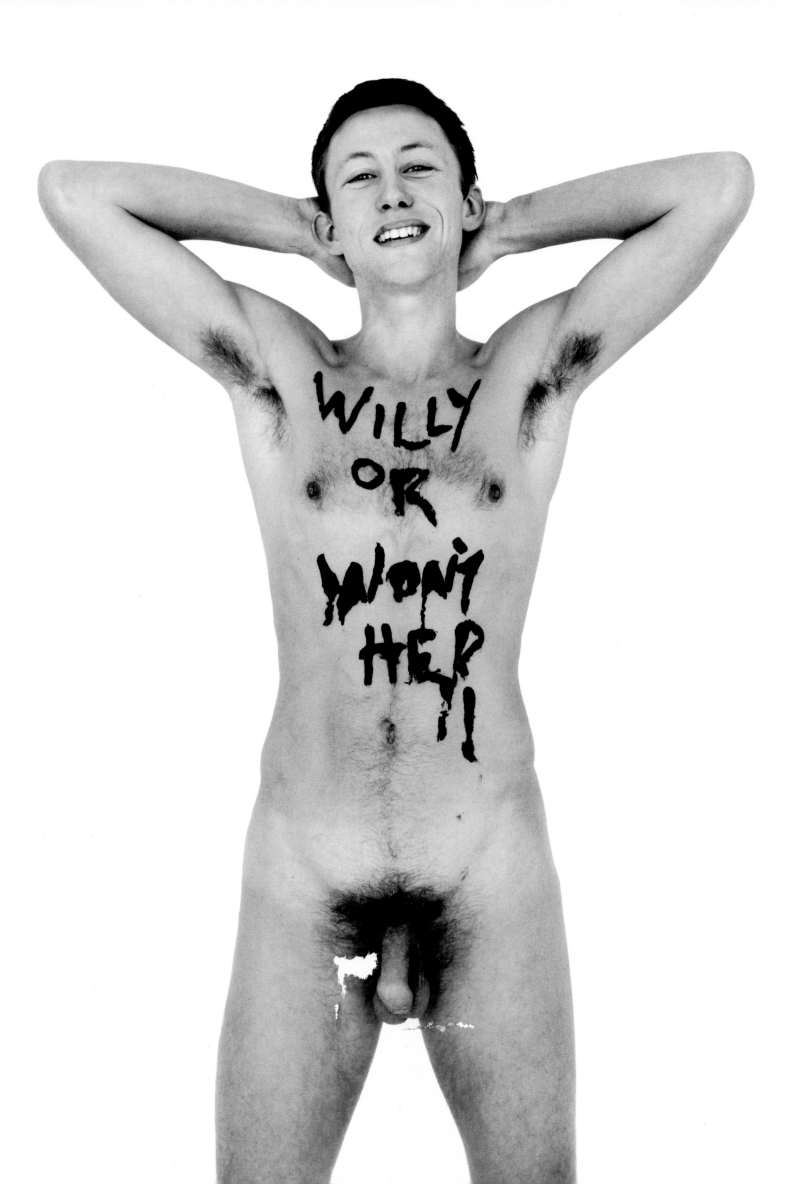

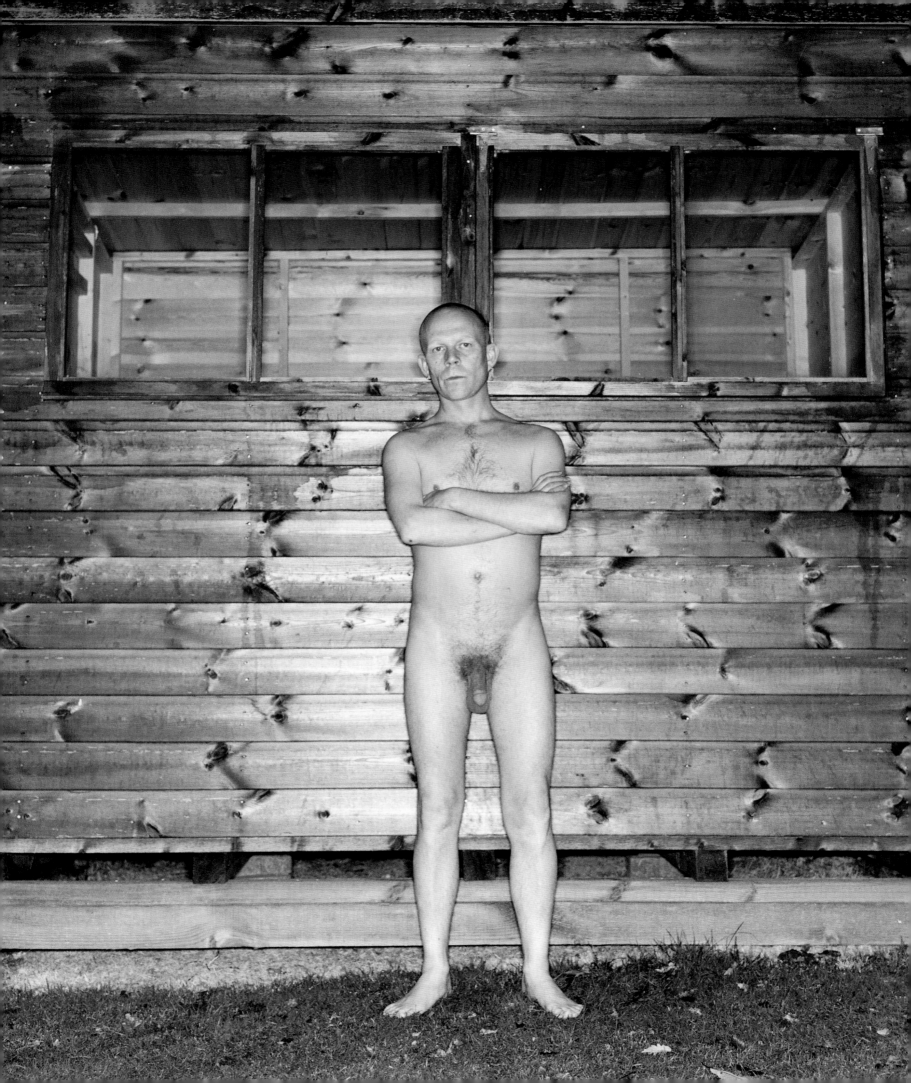

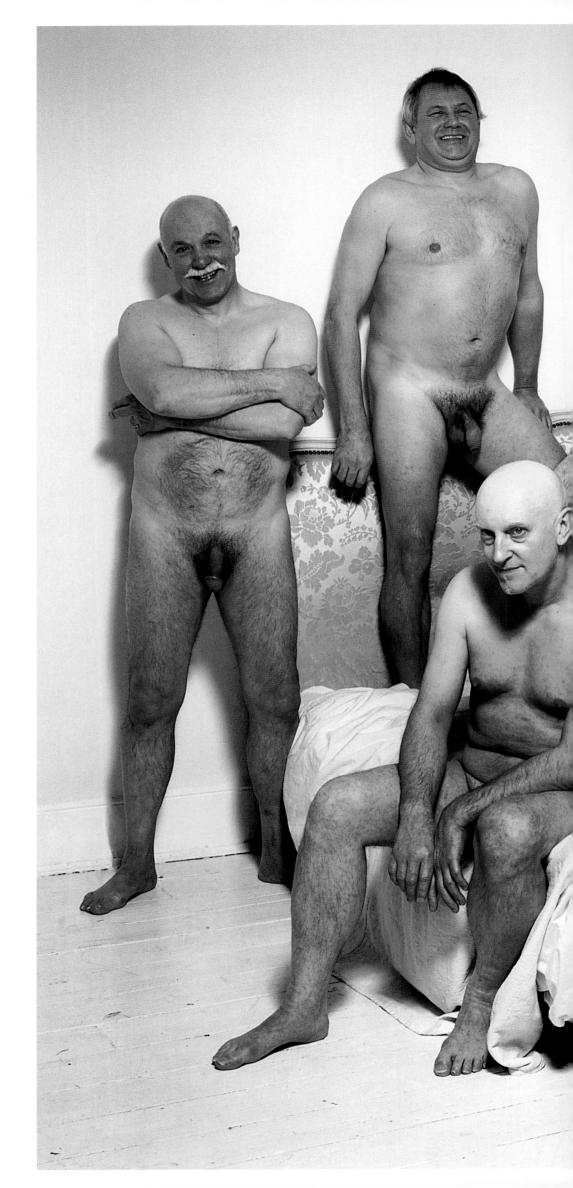

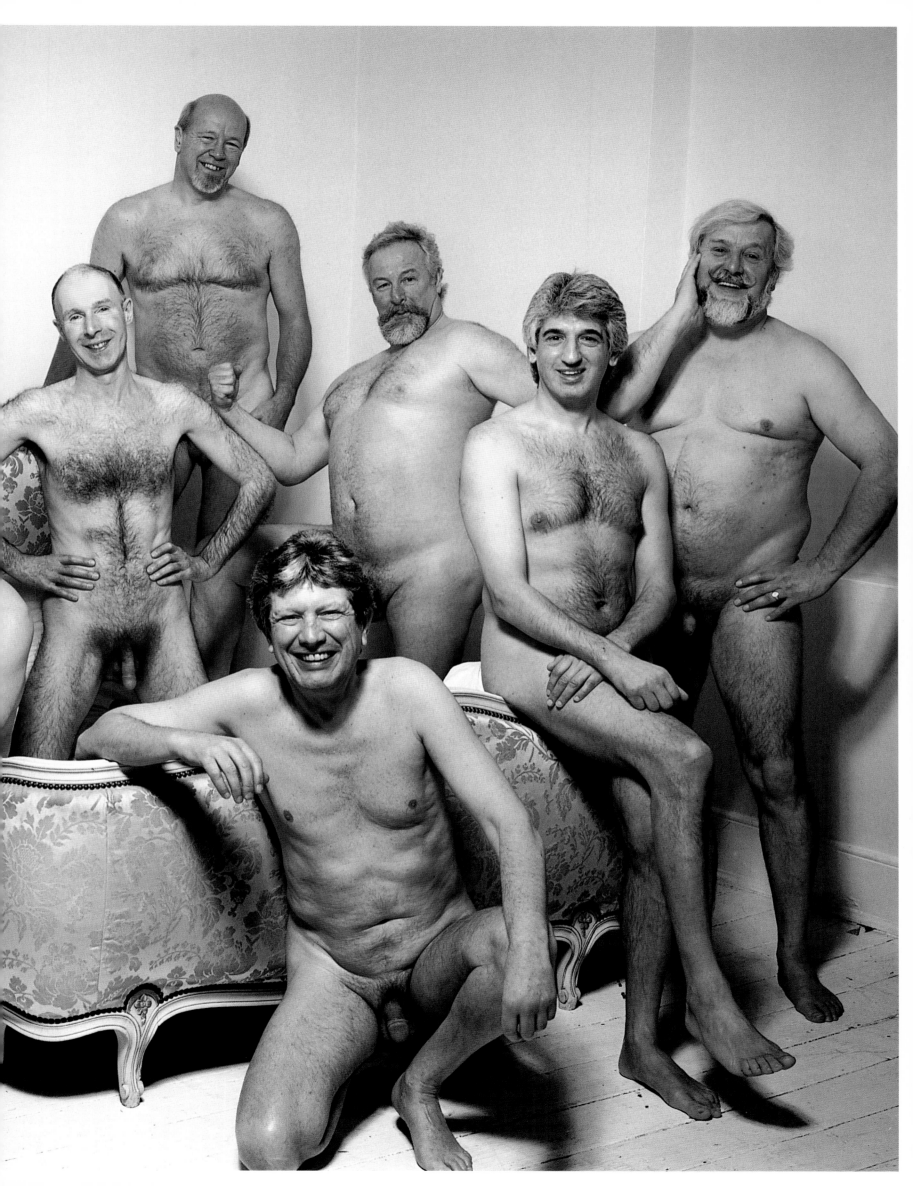

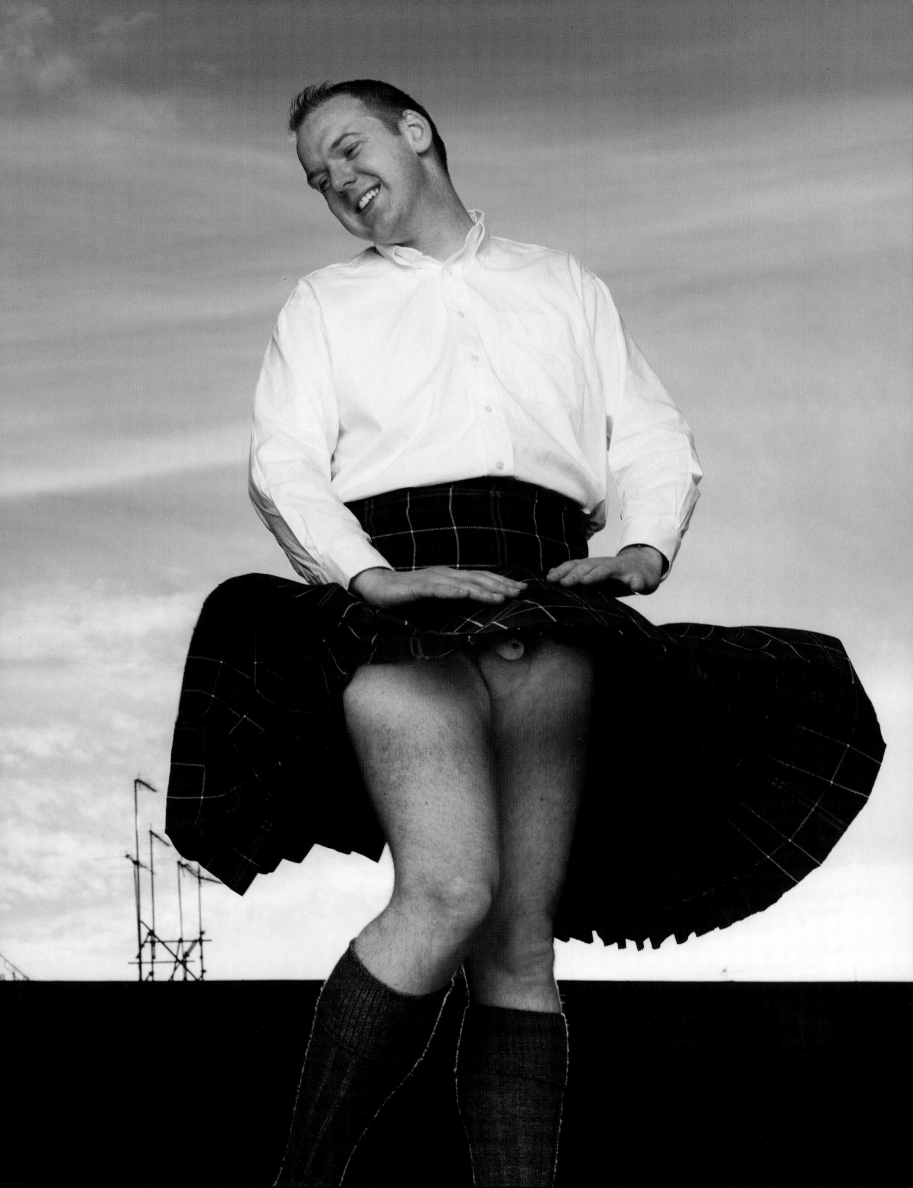

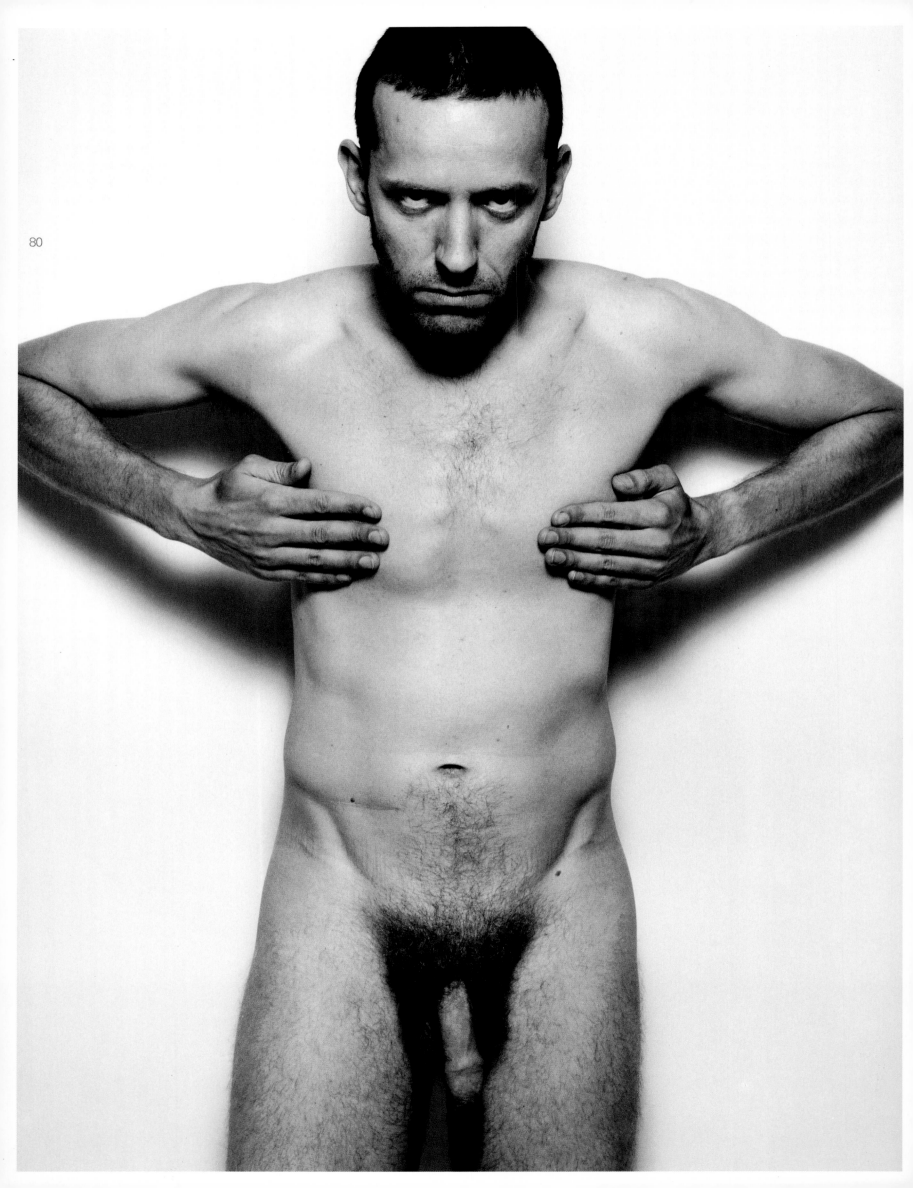

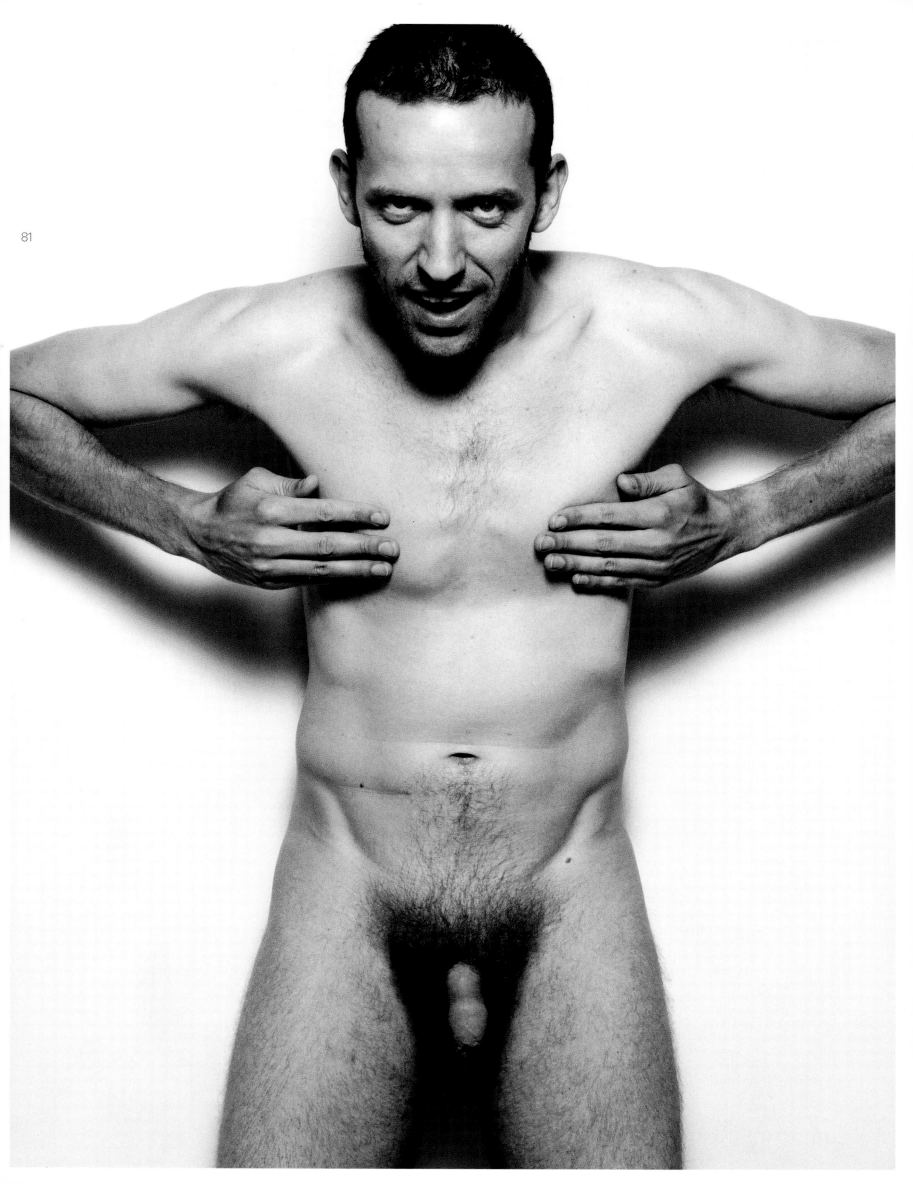

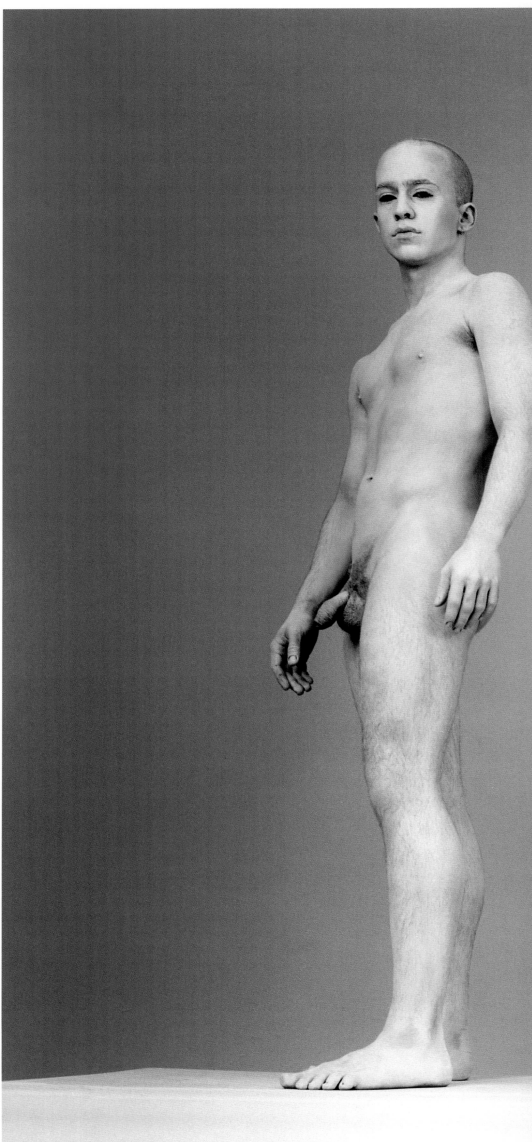

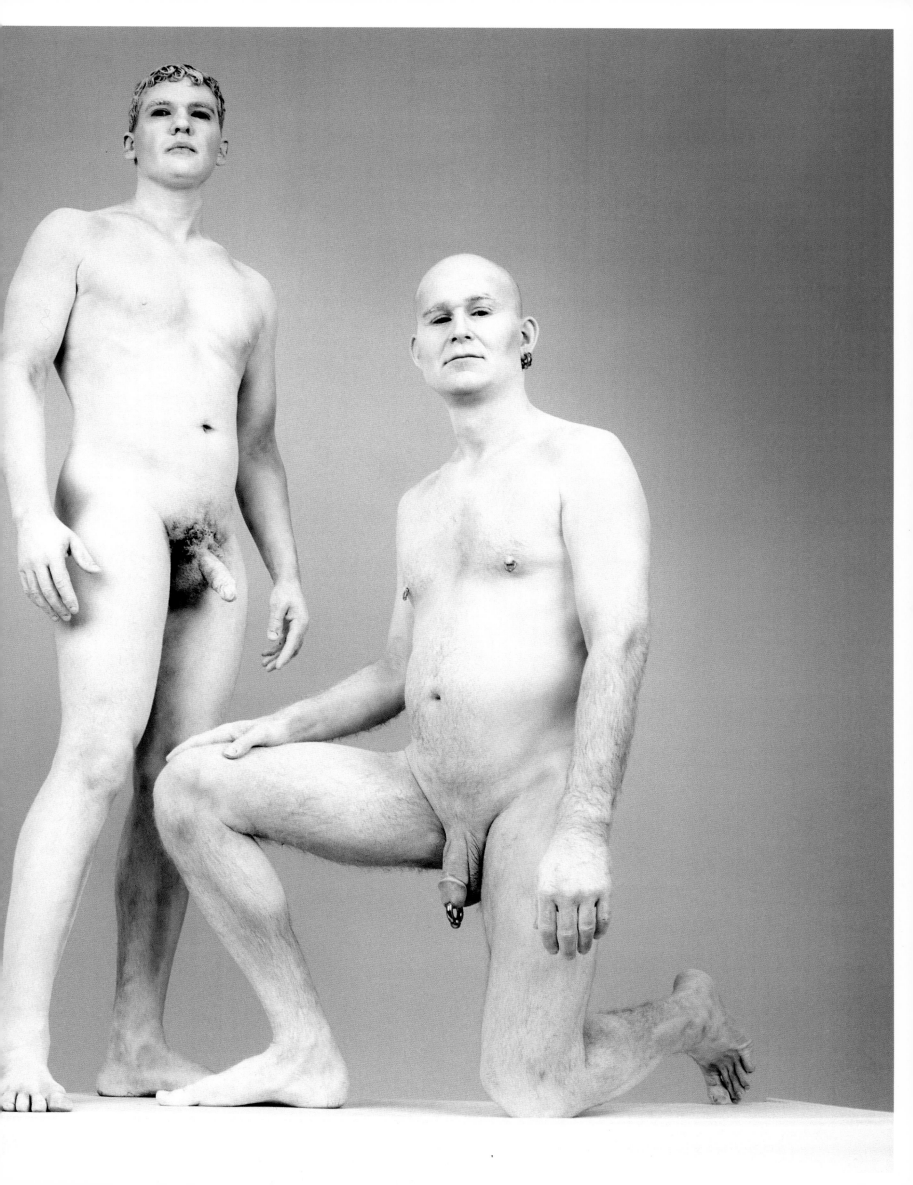

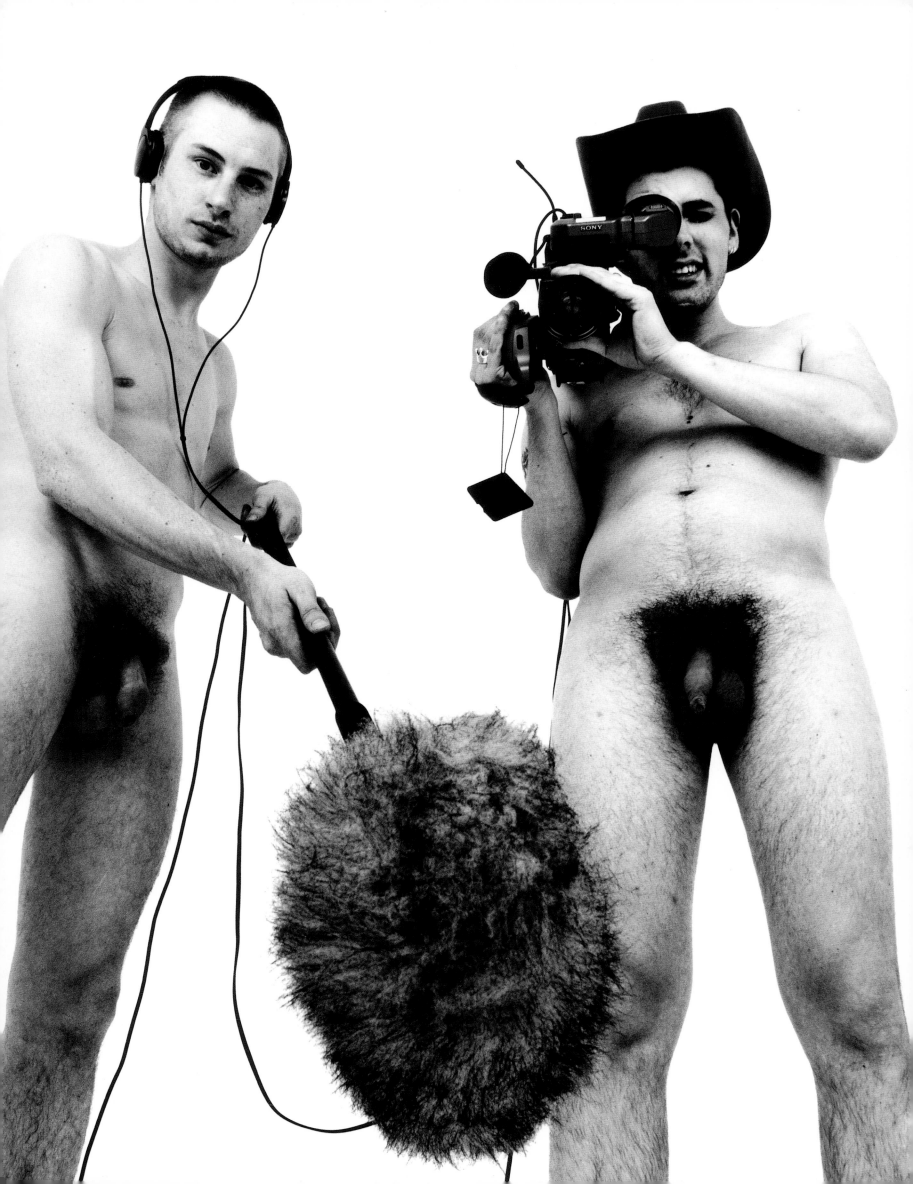

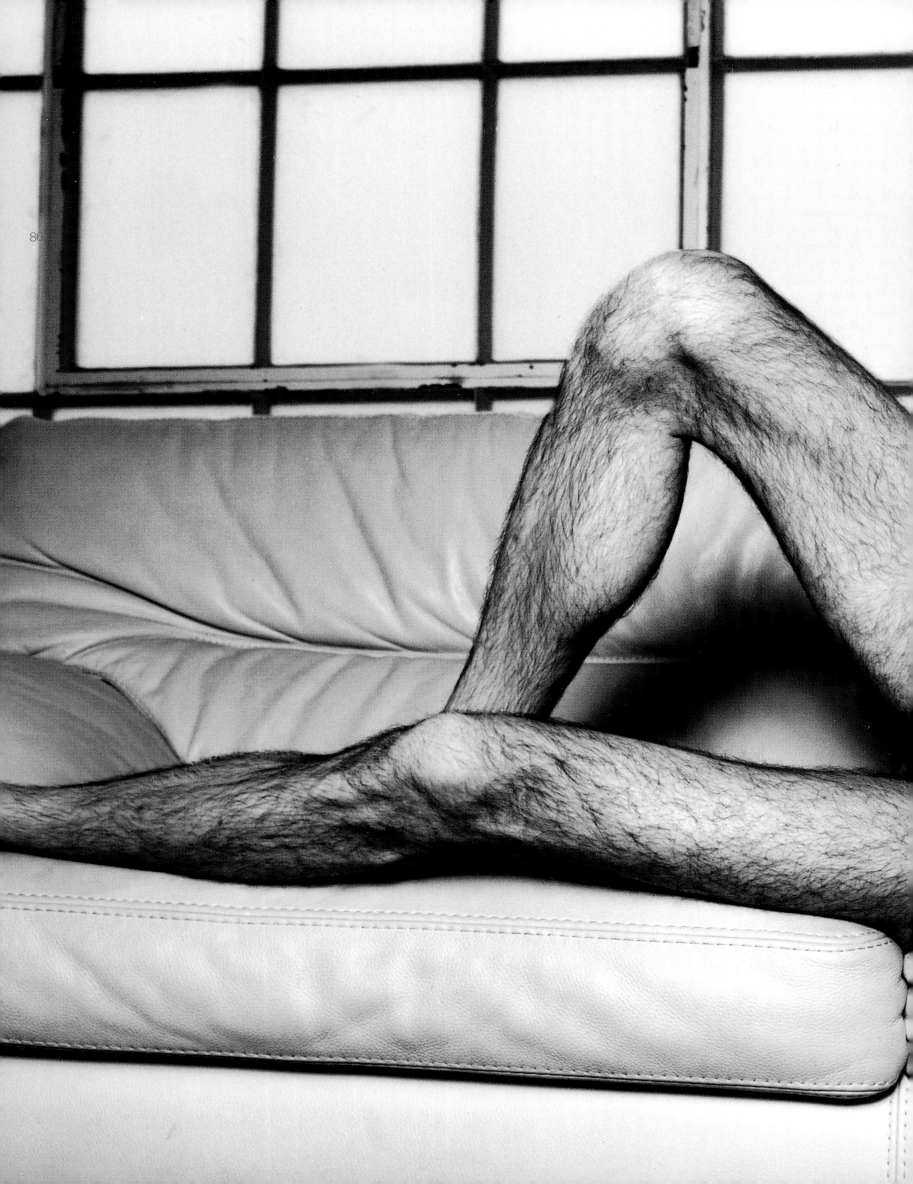

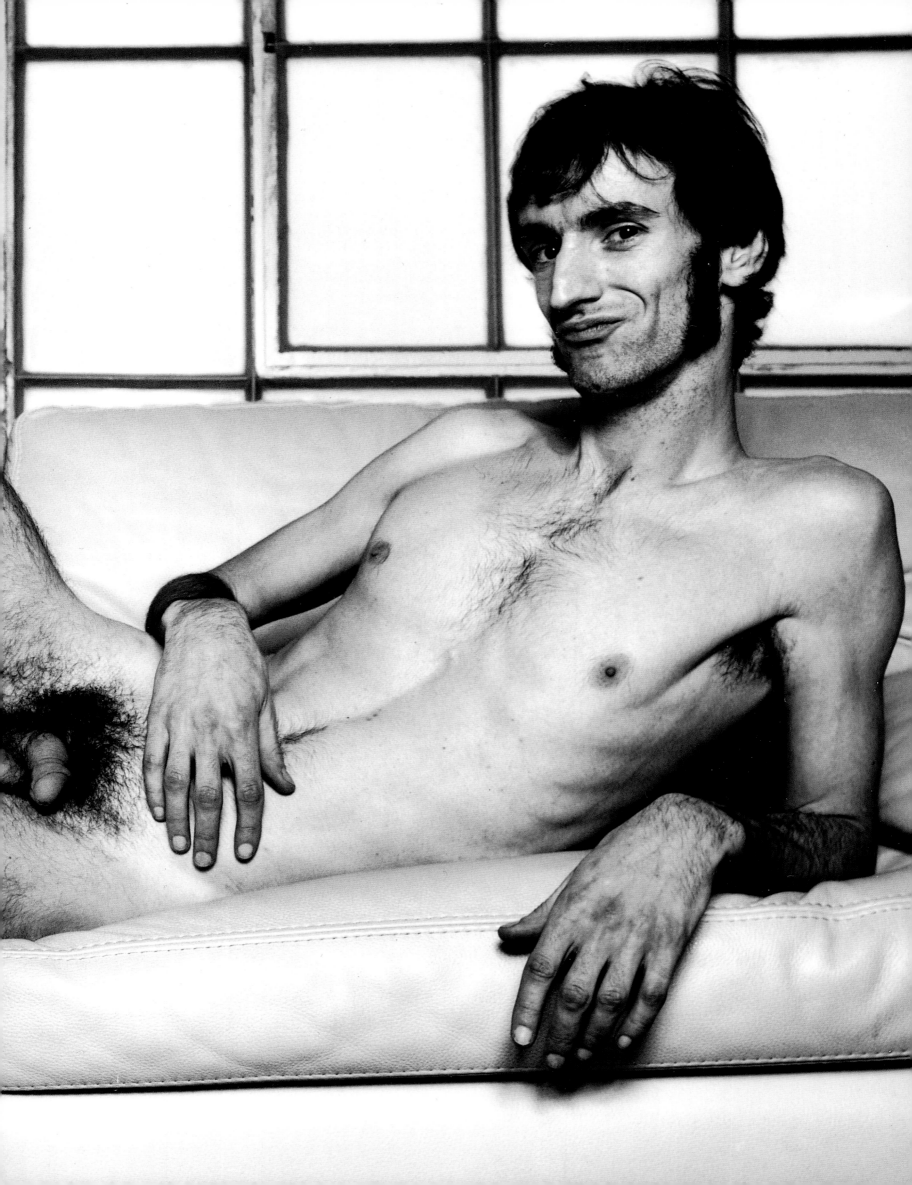

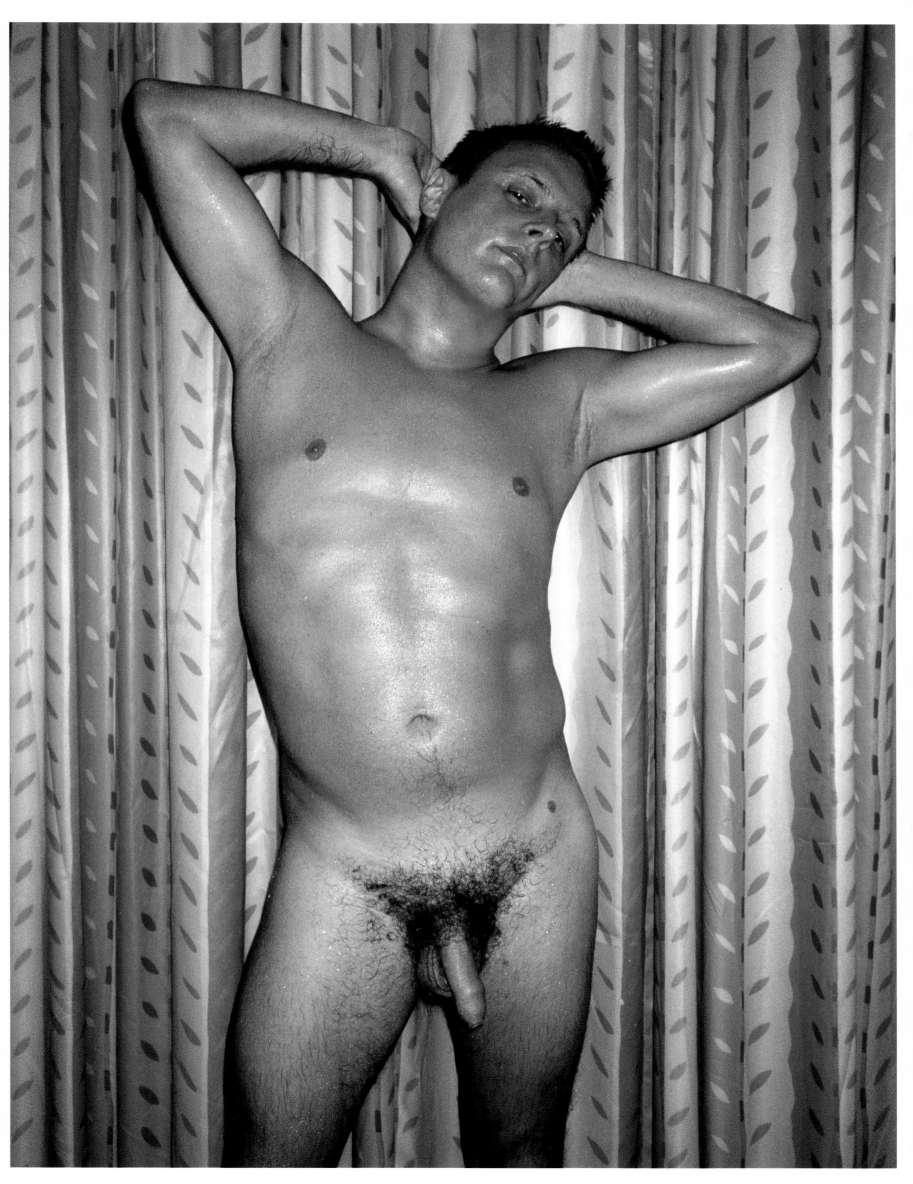

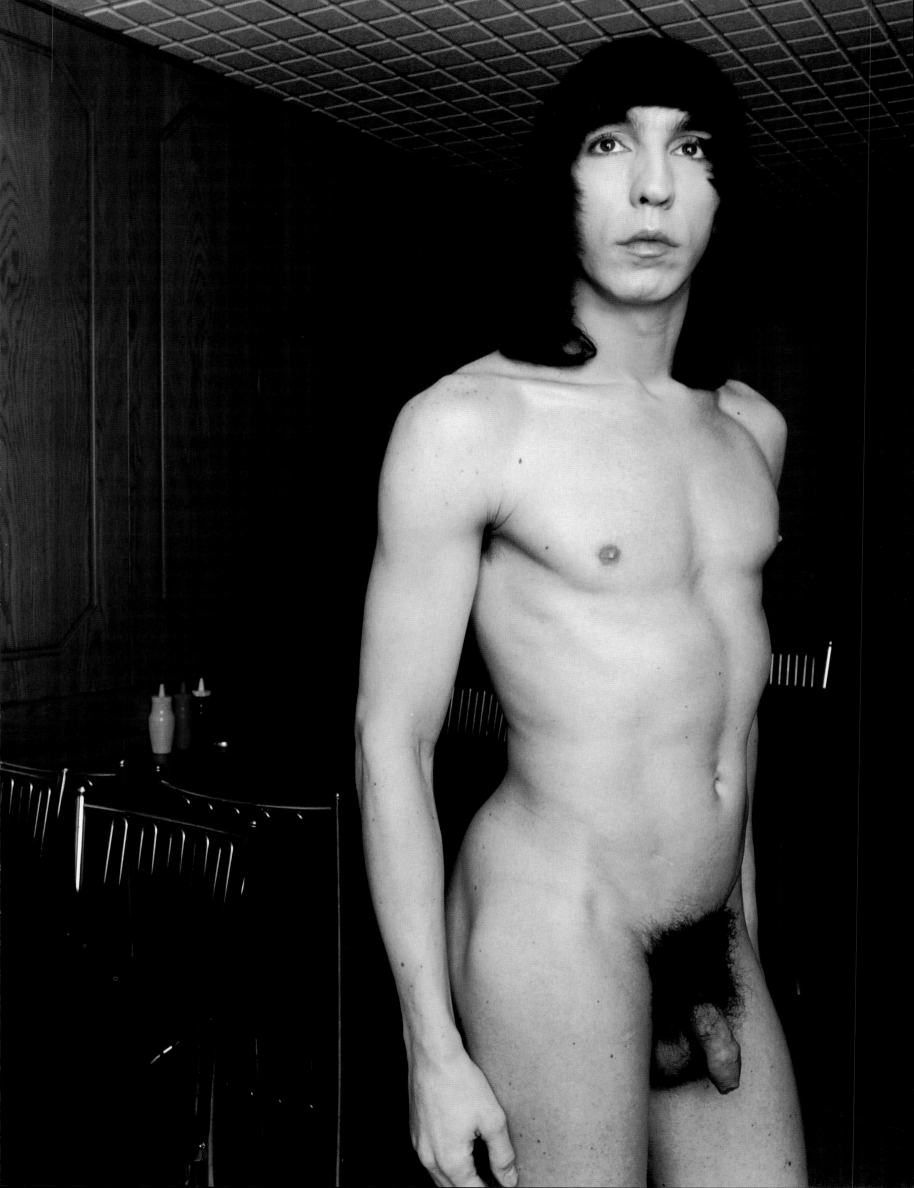

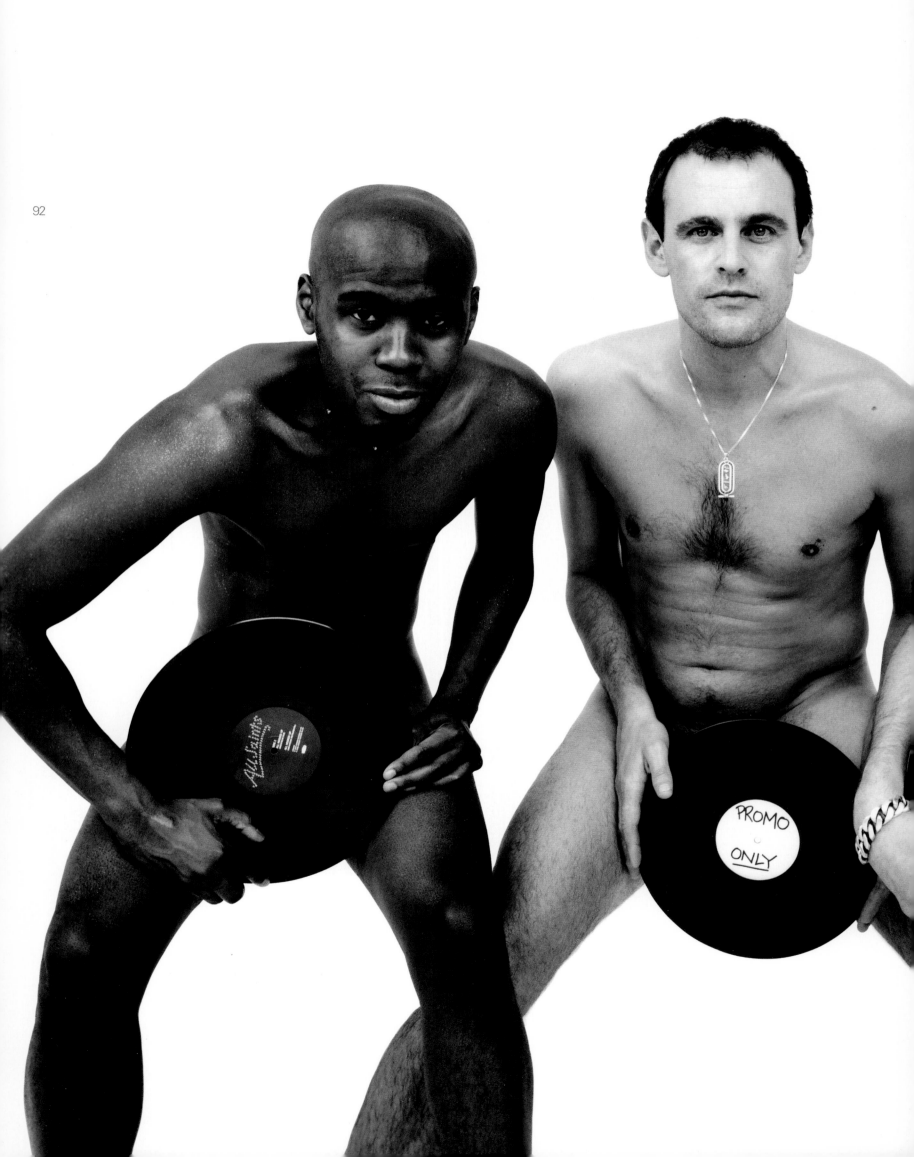

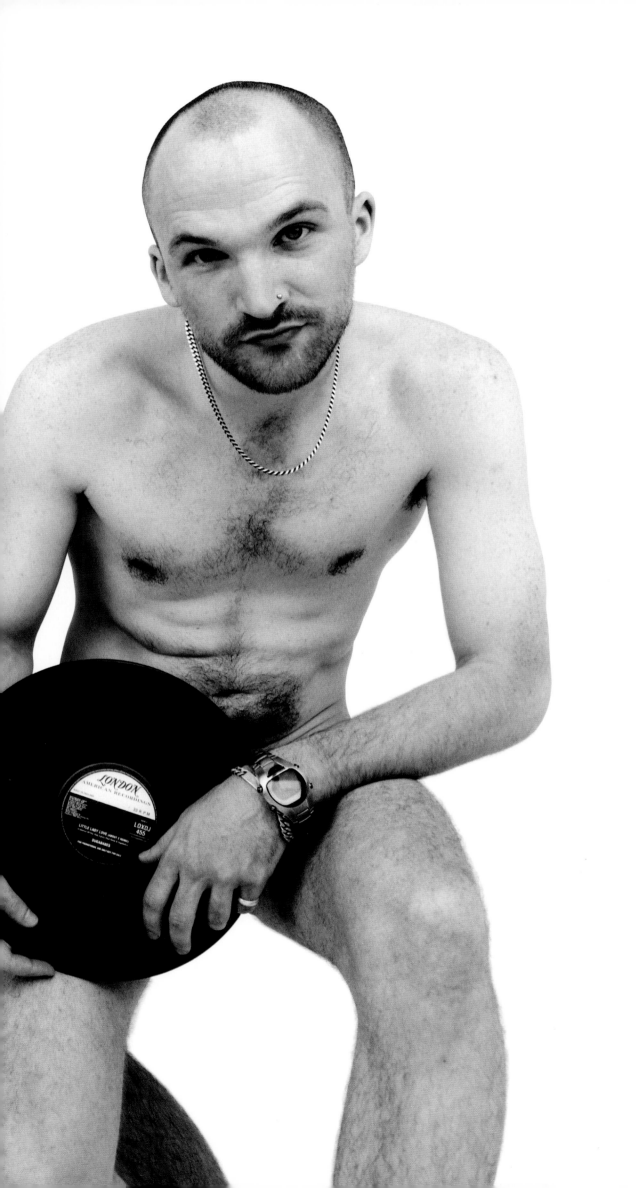

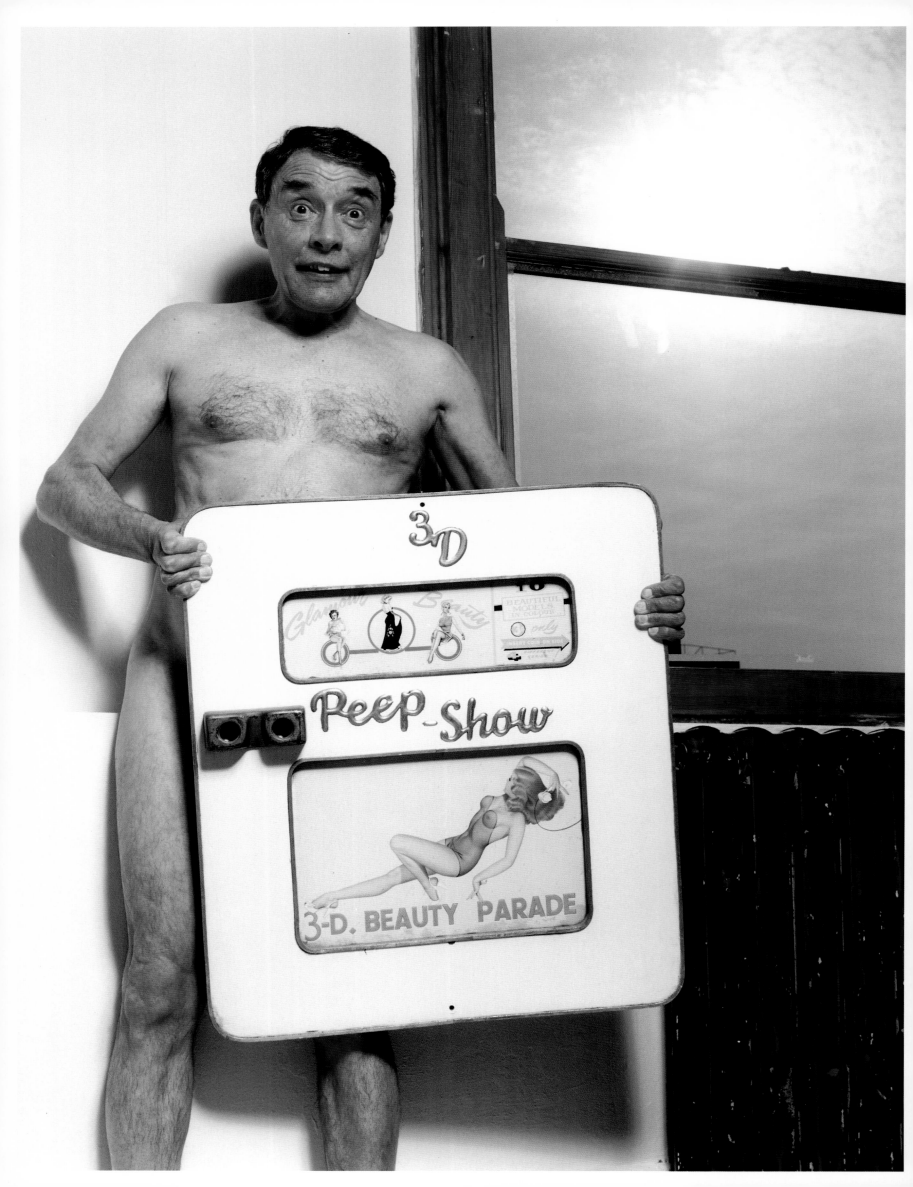

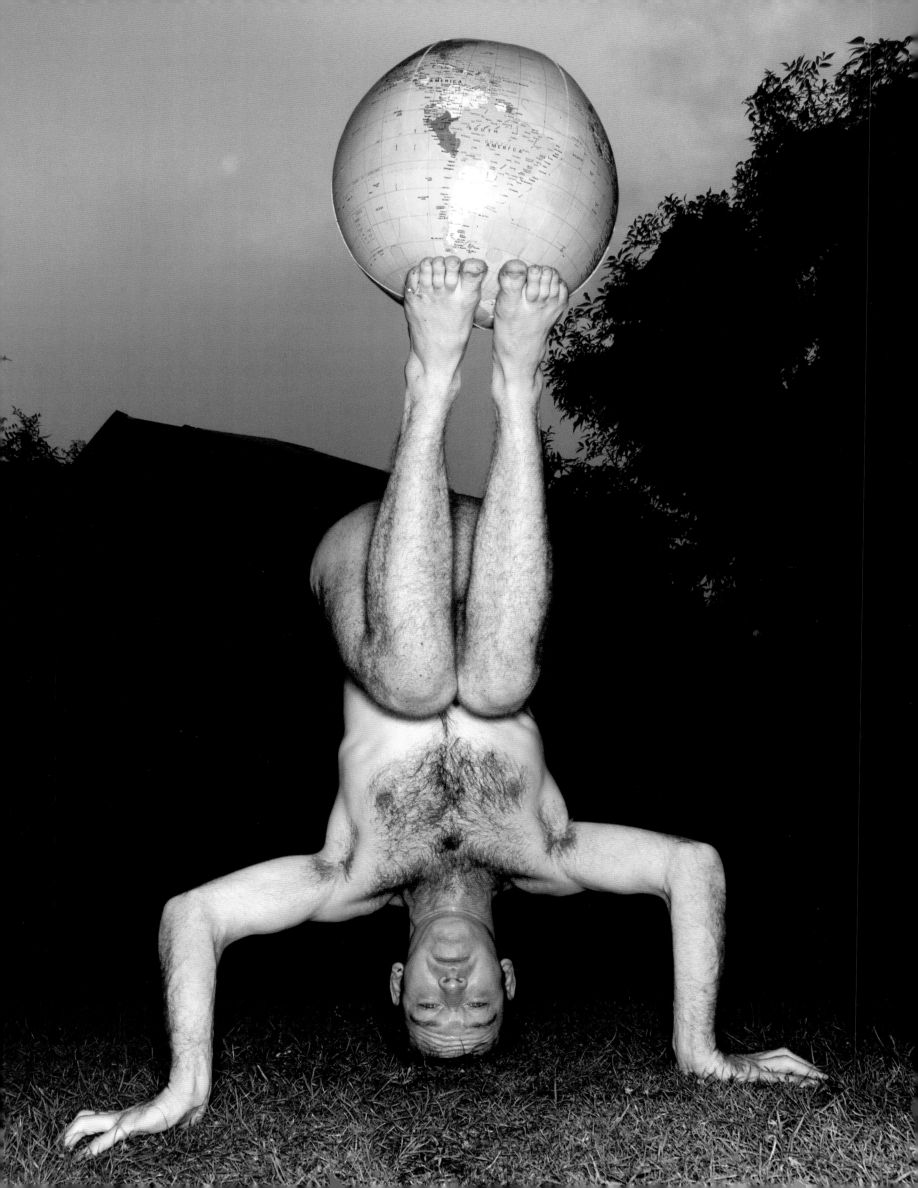

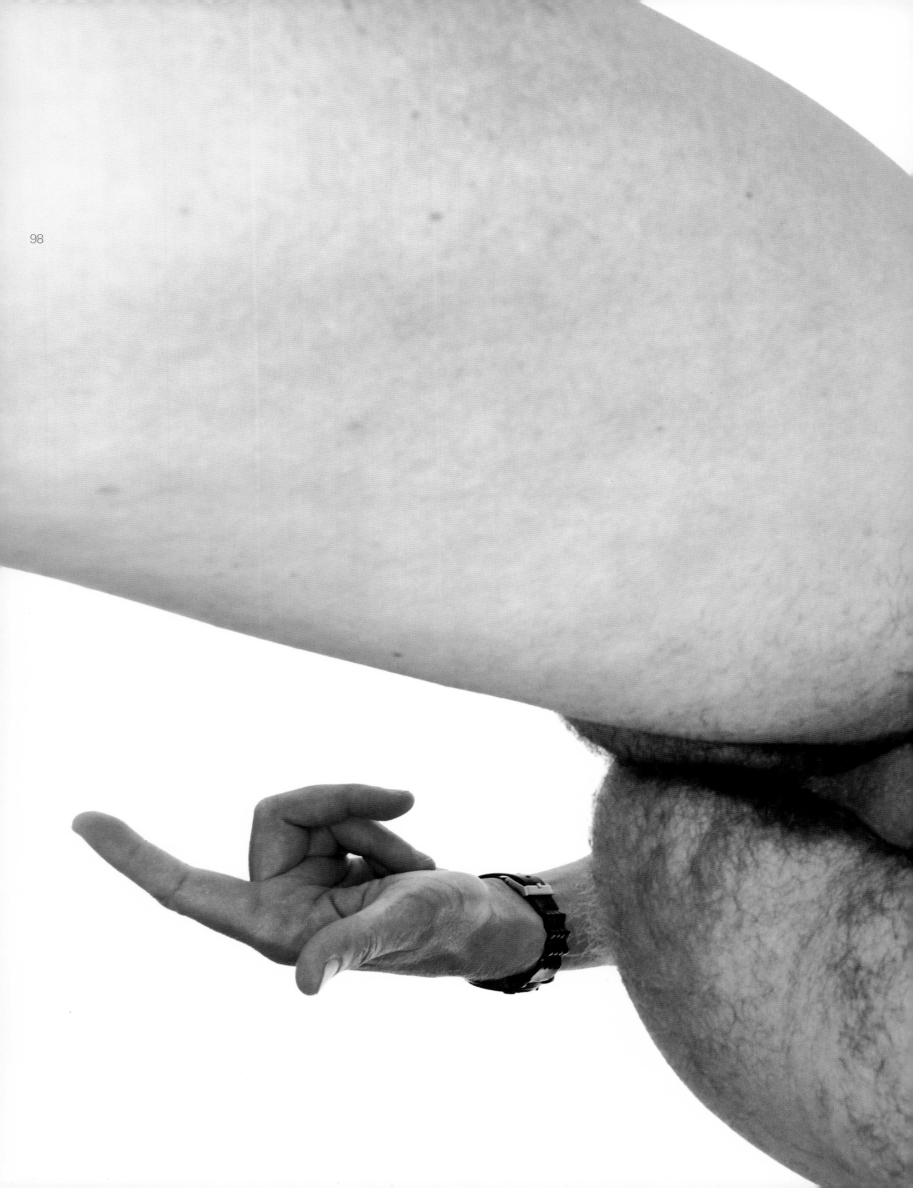

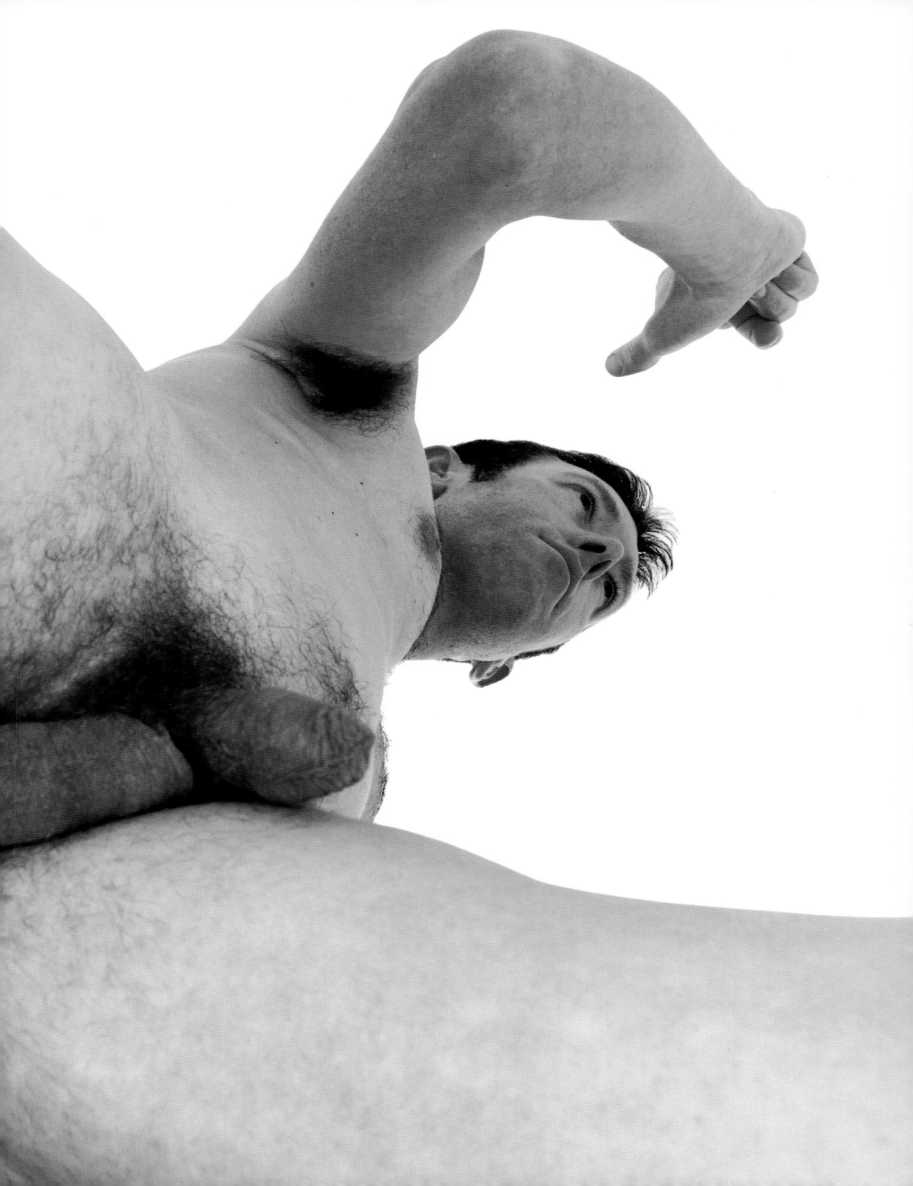

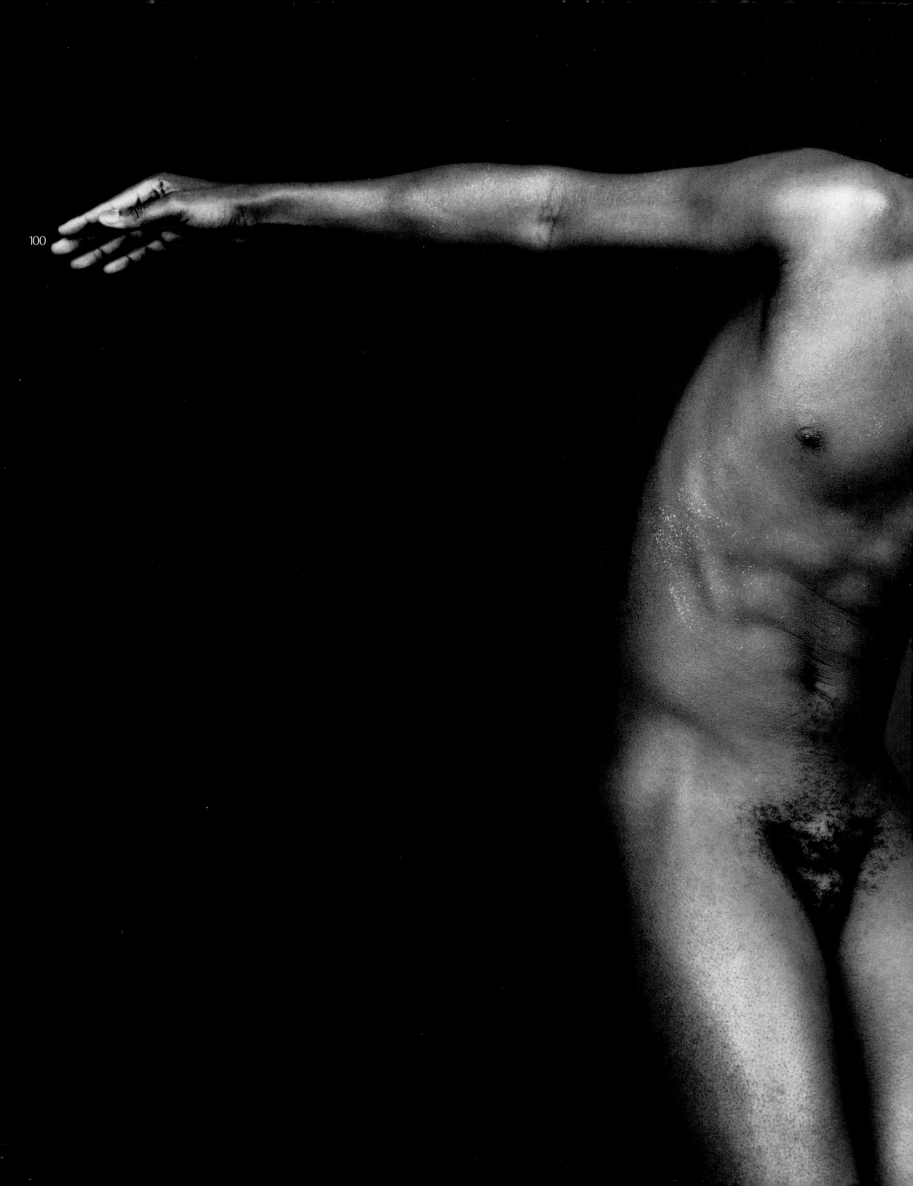

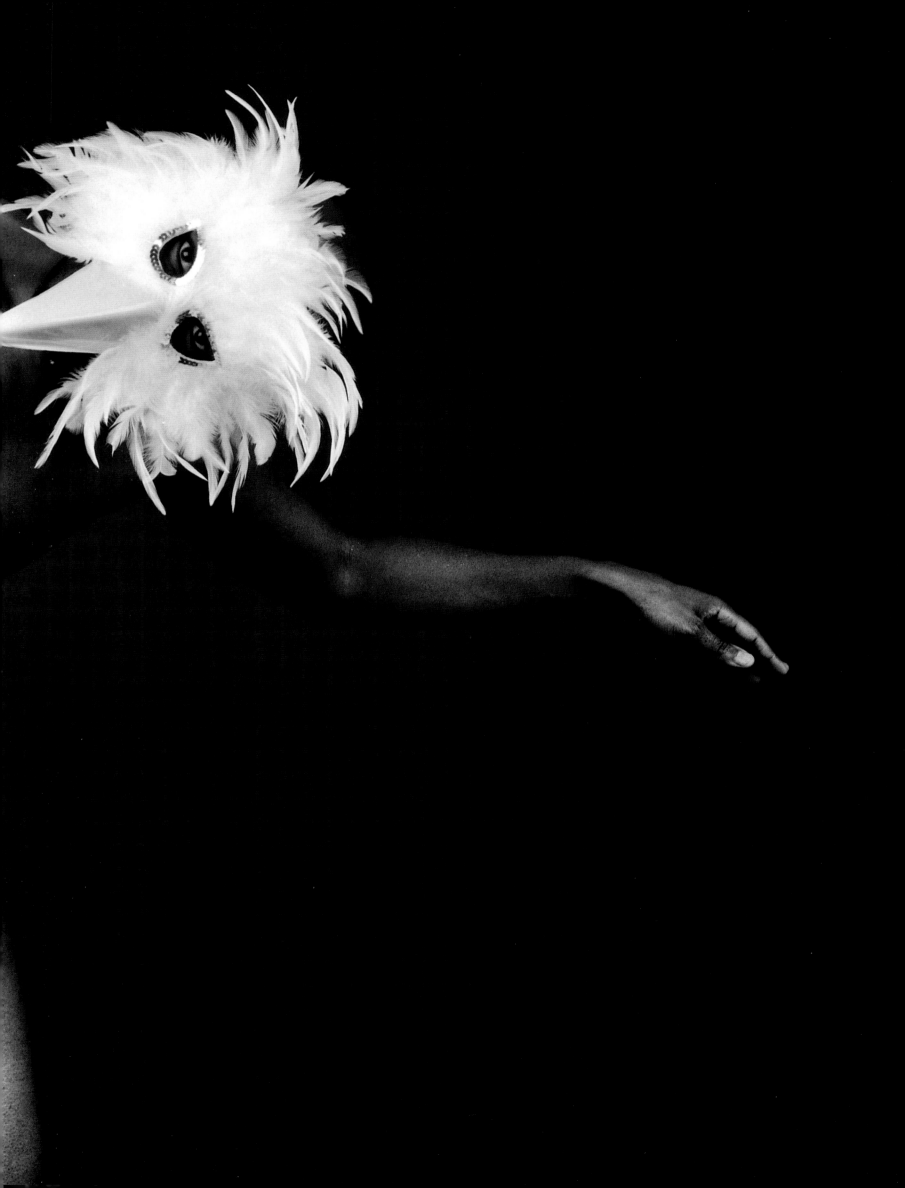

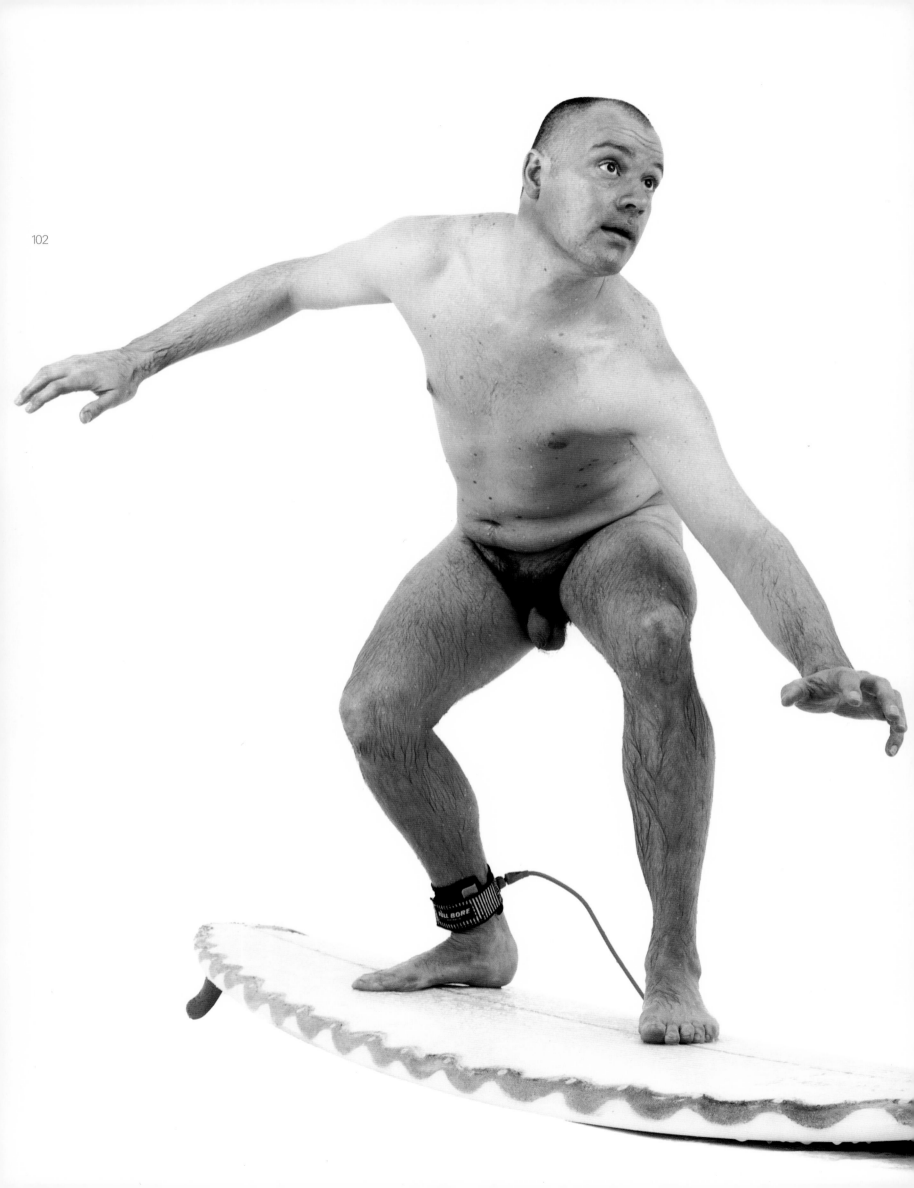

Rankin
Male Nudes

Biographies

Cover
Connor Bereen
Dazed & Confused
Studio, London

22 Jan 2001

9
Thomas Dyer
Dazed & Confused
Studio, London

3 July 2000

10
Howard Flatebo
Dazed & Confused
Studio, London

14 Nov 2000

12
Howard Flatebo
Dazed & Confused
Studio, London

14 Nov 2000

15
Mark and
George Jones
Dazed & Confused
Studio, London

11 Dec 2000

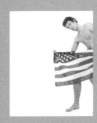

Connor Bereen
see page 25

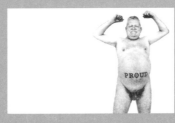

Thomas Dyer
'I went to have a look at
Rankin's exhibition of naked
women, and there was a sign
saying they were going to do
a similar project with men and
they would be giving some
money to a cancer charity.

Now I have a beef with cancer;
it killed my grandfather and
my father. So I saw it as my
Christian duty to volunteer.'

Howard Flatebo
'It's all about focus. I wanted
to have the focus on my
stomach, so it reminds me
when I grow older that I
actually did have a six pack
when I was young.'

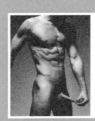

Howard Flatebo
see page 10

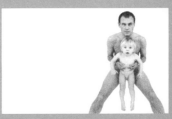

Mark and George Jones
Mark has worked with Rankin
on various projects with his
record label, Wall Of Sound.

He wanted a shot of himself
and his son George for posterity,
and the image captures this
incredibly active child in a rare
moment of stillness.

22
Daniel Marcolin
Dazed & Confused
Studio, London

23 June 2000

25
Connor Bereen
Dazed & Confused
Studio, London

22 Jan 2001

27
Sedrick Garcia
Dazed & Confused
Studio, London

16 Feb 2001

28
Aaron Zorzo
Dazed & Confused
Studio, London

17 Feb 2001

31
Damien McCown
Dazed & Confused
Studio, London

26 Oct 2000

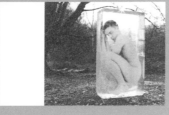

Daniel Marcolin
As a child, living beside a
canal in Burgundy, Daniel saw
a goat frozen underneath the
ice: 'I still remember that sharp,
detailed, quiet image. It was
surreal and puzzling more than
scary; more beautiful than
gloomy. That's how I'd like to
be seen, a naked body under
frozen water.'

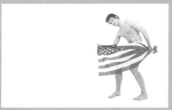

Connor Bereen
Connor was recommended
for the project by the model
agency, Nevs.

Although Irish, Connor saw an
American flag in the studio and
thought it would be interesting
to jazz up the straight studio
bodyshots.

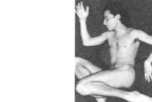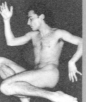

Sedrick Garcia
Sedrick is a circus performer,
who works with trapeze,
stilts and fire sticks. Having
been offered the use of a
prototype chair from Shelley
Rodgers, Sedrick decided it
would be the perfect shot
for someone who can twist
and move so freely.

Aaron Zorzo
Aaron is a model who found
out about Male Nudes through
a friend.

The cowboy shot came about
simply because he has a great
pair of boots claimed from a
fashion show and hasn't been
able to part with them yet.

Damien McCown
Originally from New Zealand,
Damien was a champion
trampolinist and wanted to
convey both his athleticism
and culture.

He wanted to draw a full
moko (Maori face tattoo) on
himself but he was such a
great subject for a movement
shot, the full somersault
image won out.

16
Ben Dover
The Roost, London

20 Feb 2001

19
Anthony Agbaje
Dazed & Confused
Studio, London

30 June 2000

20
Pat Gillen
New Wharf Road,
London

6 July 2000

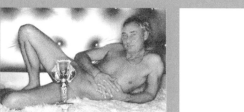 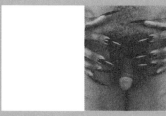

Ben Dover
Ben is well-known in the porn industry, having written, directed and starred in many films.

The trophy, an award for his achievements in the industry, subtley hides something that is normally on display for him.

Anthony Agbaje
'This is the first time in my life that I have been confident about my body. There's all this stuff about penis size and 'Have I got the right pecs', but actually I am very happy with the package I have been blessed with.'

Pat Gillen
Pat decided to get involved in order to focus on cross-gender issues in a glamorous way. It was an opportunity for the accomplished jazz pianist to show off 'a beautiful body'.

32
Clive Cockram
Dazed & Confused
Studio, London

12 July 2000

33
Howard Marks
The Roost, London

20 Feb 2001

34
Anthony Agbaje
Dazed & Confused
Studio, London

30 June 2000

36
Christopher
Dazed & Confused
Studio, London

22 Jan 2001

37
Ose
Dazed & Confused
Studio, London

16 Feb 2001

38
Simon Brilliant
Wilberforce Road,
London

21 Nov 2000

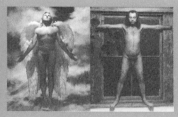 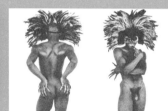 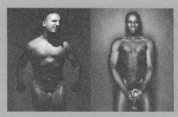 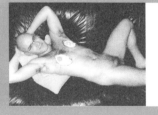

Clive Cockram
Clive is a writer who told us he wanted to be portrayed as an angel/devil split personality, to show the good and evil that exists in everyone.

Wearing angel wings and floating in the sky whilst having an erection represents the devilish side of angels. The box he stood on was eliminated by computer.

Howard Marks
Howard is a disc jockey who roams about doing functions most nights of the week, and does extra work in TV and film. He thought that a nude photo shoot would be fun and 'something to add to the CV'.

Anthony Agbaje
'When I found out that Rankin had shot Madonna, I thought 'OK, you can photograph me too'. I took along the mask because I didn't want to show all of my face. I wanted to keep an air of mystery.'

Christopher
Christopher is a script writer and diver in the film industry and wanted to focus on lighting for his photo. After trying a few different set-ups it was decided strong light from above worked the best.

Ose
Ose wanted to show his mastery with his tool. This shot recalls one which appeared in Rankin Nudes, showing Daphne Crosby holding a Darth Vader mask.

Simon Brilliant
'Me and my girlfriend talked about what I should do and we came up with the fried eggs in the style of Sarah Lucas. She did two fried eggs and a kebab; I did two fried eggs and a sausage.

Part of the reason for doing it was to have a picture of myself before I grow old and everything goes saggy.'

41
Robert Burton
Old Street, London

30 June 2000

42
John Callaghan
Dazed & Confused
Studio, London

26 Oct 2000

45
Damien McCown
Dazed & Confused
Studio, London

26 Oct 2000

46
Tom Benn
Dazed & Confused
Studio, London

17 Jan 2001

48
Lars Skold
Dazed & Confused
Studio, London

30 June 2000

49
Touché
Dazed & Confused
Studio, London

11 Dec 2000

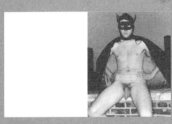 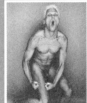

Robert Burton
'I wanted to dress up as Batman because I think there's something in my personality that's like him. I'm not sure what. I also liked the TV series and the kitsch-ness of it.'

John Callaghan
John is a life model with a lot of experience in front of both lens and drawing boards.

His 'trophy board' idea can be interpreted in many different ways. Women tended to look at is as something to be put on their wall, and men seemed to want to write the names of conquests on the plates around the penis.

Damien McCown
see page 31

Tom Benn
Rankin had just done a fashion shoot with animal props and Tom's favourite was the lion. His prowess as a gymnast helped him vault around the animal.

Lars Skold
'I have never been ashamed of my body. I'm not saying that I have a better body than anyone else, I just mean, what you see is what you get.'

Touché
A DJ from the Wall Of Sound crew, Touché decided on a toy gun to add a dangerous element to his shot.

57
Ben Dover
The Roost, London

20 Feb 2001

58
Ian Campbell,
Lee Adams
Dazed & Confused
Studio, London

16 Feb 2001

60
Martin Bleasdale
Dazed & Confused
Studio, London

8 Aug 2000

62
Phil Creswick
Dazed & Confused
Studio, London

22 Jan 2001

64
Robert Cohen
Dazed & Confused
toilets, London

16 Feb 2001

65
John Moysen
West Dulwich,
London

24 Oct 2000

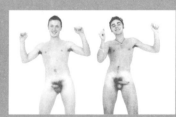 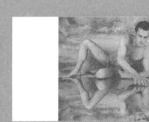 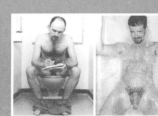

Ben Dover
This shot is not what it appears to be. The talented Ben Dover is actually swinging his penis around in a circular motion and it was captured at 12 o'clock.

Ian Campbell, Lee Adams
Ian and Lee simply thought getting naked would be good for a laugh. Full of energy, they ended up doing the twist for the camera.

Martin Bleasdale
Martin had many humorous ideas on how to be portrayed including bath tubs and rubber ducks. This one was the best, conveying serious attitude with just the right amount of humour.

Phil Creswick
Phil heard of the project through his friend Vince Clarke, and decided on a the painted backdrop for this surreal look at the story of Narcissus: 'If you get your kit off for anybody you gotta get it off for one of the best photographers in the world.'

Robert Cohen
'For me, the difficult thing about being a writer is trying to find a place to work without distractions. The toilet is, arguably, such a place – I can't fall asleep while perched there.'

John Moysen
see page 66

50
Daniel Brown,
Gary Cue
Dazed & Confused
Studio, London

16 Feb 2001

52
John Lebar
Wasteland, Eagle
Whaf Road, London

11 July 2000

54
Steve Hooper
The Roost, London

20 Feb 2001

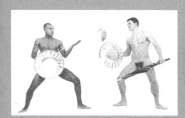

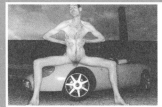

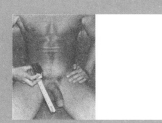

Daniel Brown, Gary Cue
Daniel and Gary had never met before this shoot. After sitting in the studio waiting for their respective shots, they came up with the idea of a mock war with umbrellas and office bin lids.

John Lebar
'I am 7 feet tall and I used to think it was terrible to have a body like mine. But as I've got older, I have begun to get used to it. I'm into ways of controlling how people see me.

It was my idea to be photographed stretched over the car in a tacky porno pose. It's the sort of image that you always see of women, and I wanted to subvert that.'

Steve Hooper
The well-endowed Steve was the perfect choice to portray the ever present obsession with penis size.

It was almost inevitable that a tape measure would extend itself somewhere in the project.

66
John Moysen
Dazed & Confused
Studio, London

24 Oct 2000

68
Ariel Amejeiras
Outreal Studios,
London

22 Nov 2000

71
Lars Skold,
Derek Easter
Dazed & Confused
Studio, London

30 June 2000

72
Michael Faye
Dazed & Confused
Studio, London

16 Feb 2001

73
Michael Bean
Dazed & Confused
Studio, London

27 Oct 2000

74
Vincent Clarke
Staines

9 Dec 2000

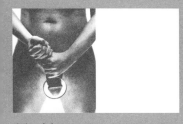

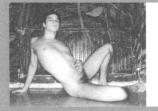

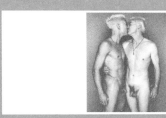

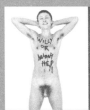

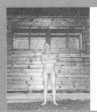

John Moysen
John is a graphic designer living in London. He sent in a page of sketches with many ideas on it and the one that caught the most attention was the magnifying glass, a quirky way of dealing with the male size issue.

Ariel Amejeiras
Ariel is a songwriter and producer and wanted to be shot outdoors in a 'Midsummer's Night Dream' environment. Since the middle of winter in the UK doesn't lend itself to shooting naked men outside, set builder Fil Stokes suggested we use his own flat, which he has transformed into a jungle.

Lars Skold, Derek Easter
Lars came in for the casting day and explained that he had two friends who were also interested in posing together.

His original idea was for the final image to appear plastered over a paint-splattered billboard but the simpler image of two of the friends together was stronger.

Michael Faye
After seeing some of the earlier images for the project Michael liked the humour in the work. He wanted to continue this theme using humorous text on his body.

Michael Bean
Michael originally wanted to be photographed 'in a field of bright yellow rape with a blue sky either standing or possibly jumping into the air.'

Bad weather meant that his shoot had to take place in the studio where the full glory of his new wings tattoo could be kept dry.

Vincent Clarke
Vincent Clarke, formerly of Depeche Mode and currently half of Erasure, expressed his interest in being a part of the project through a friend of Rankin's.

After meeting up and visiting Vince's amazing house, Rankin asked Vince to choose favourite spots. This shed was used to house Vince's recording equipment and he's spent many a long night there.

76
John Denton, John
Benjamin, Dave Moore,
Ian Wilson, Steve
Adams, Mike Barnett,
Joe Hepworth, Morris
Davis, John Percival
The Roost, London

20 Feb 2001

79
Alex McFadyen
Old Street, London

21 Nov 2000

80
Paul Facer
Dazed & Confused
Studio, London

30 June 2000

82
Jorge Balca, Kevin
Saldanha, Nigel Politzer
Dazed & Confused
Studio, London

24 Nov 2000

84
Charlie Strand
Dazed & Confused
Studio, London

1 July 2000

85
Simon Allen,
Chris Cottam
Dazed & Confused
Studios, London

18 Feb 2001

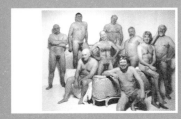 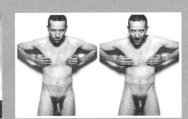 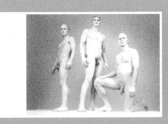 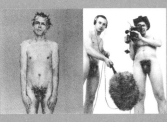

John Denton, John Benjamin, Dave Moore, Ian Wilson, Steve Adams, Mike Barnett, Joe Hepworth, Morris Davis, John Percival
After the group shot done for the female Nudes book it was decided to shoot a group of men for Male Nudes so a request went out to Jayne Collins Casting.

The above nine replied with reasons ranging from 'I agreed to be shot as nature made me just to show how mistakes are made', to 'I thought it would be nice to be involved with something artistic and at the same time help a worthwhile charity.'

Alex McFadyen
Alex, a designer, put forward this Marilyn Monroe-esque idea with a twist. Being Scottish, he wanted to do a cheeky shot with his kilt: 'I guess there is that voyeuristic thing about naked people, you do want to see them.'

Paul Facer
Paul wrote in with an idea for a series of photographs depicting temperature change in men's genitalia. This is one of the more subtle ideas submitted for the project.

Jorge Balca, Kevin Saldanha, Nigel Politzer
Jorge, Kevin and Nigel were keen on being involved in the project and interested in the classical theme of this shot, which enlisted the help of Emma Miles and Rebecca Kerr – the bravest body painters on the planet.

Charlie Strand
'I have always been fascinated by ice, perhaps because I am half Icelandic, and so I came up with this idea to use special-effects make-up to make it look as though I was frozen. It took four hours to do the make-up.' Thanks go to Lisa Houghton and Shinya Nakayama for their skillful application of the 'ice'.

Simon Allen, Chris Cottam
Chris and Simon followed some of the subjects in this book for a television documentary, detailing the entire process, from applications to castings, shoots and finally the hanging of the exhibition. It seemed fair to include them in the photographs.

91
Gianni Rochetta
Old Street, London

23 Nov 2000

93
Mike Beatnik, Mark
Jones, DJ Touché
Dazed & Confused
Studio, London

11 Dec 2000

94
George McLeod
The Roost, London

20 Feb 2001

97
Patrick Quilty
Old Street, London

8 Aug 2000

98
Ciaran Bregazzi
Dazed & Confused
Studio, London

17 Feb 2001

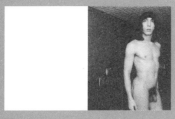 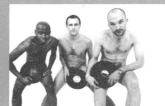

Gianni Rochetta
Originally from Italy via New York, Gianni was living in London and doing singing tuition when friends mentioned the advertisement in Time Out.

Gianni worked as a life model for many years in New York, and wanted 'a renaissance feel' to reflect his personal look. The final 'kebab shop' location makes for an intriguing juxtaposition. Thanks a lot to Orannah HK for the make-up.

Mike Beatnik, Mark Jones, DJ Touché
Artists and MD of Wall Of Sound Records, they decided to keep the theme going with some extremely well-placed vinyl.

George McLeod
'Any project associated with cancer awareness is a worthwhile bedfellow.

Additionally, I enjoy reminding myself and the world that youth does not have a monopoly on life, and that I have all my own hair and teeth, plus a not unreasonable body at the age of sixty.'

Patrick Quilty
Patrick is a single parent, and wanted to convey the way his world is normally upside down and back to front juggling work and a child.

Ciaran Bregazzi
Ciaran wanted to be 'shot from below jumping/running over the camera, white running shoes and bleached blonde hair, no hair on legs or body'.

86

Darren McFerran
Shoemakers Elves
Studio, London

16 Feb 2001

89

Rankin
Almond Beach
Club, Barbados

15 Jan 2001

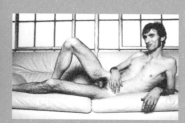

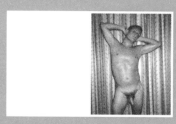

Darren McFerran
An actor and DJ, Darren
wanted to be involved because
'Anything that promotes the
beauty of the human body
has got to be good. And it's
for charidee mate!'

Rankin
'I felt like I had to because
everybody else did.' Thanks
to Miranda Robson for
this shot of Rankin relaxing
on holiday.

100

Mike Beatnik
Dazed & Confused
Studio, London

11 Dec 2000

102

Philip Ball
Dazed & Confused
Studio, London

16 Feb 2001

104

Tristan Temple
Dazed & Confused
Studio, London

22 Jan 2001

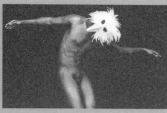

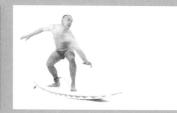

Mike Beatnik
Mike heard of the project
through his record label Wall
Of Sound and was brave
enough to get involved.
He brought in his own white
bird-like mask, either to show
it off or hide behind it.

Philip Ball
Phil brought in his surfboard
and the original idea was to
shoot on the roof with a lovely
blue sky backdrop.

Due to the English weather
it was necessary to move
the shoot inside and add a
bucket of warm water. In his
own words, 'My wife dared
me, so here I am.'

Tristan Temple
Tristan brought in a couple of
props for his shoot but after
discussing with Rankin the idea
of being wrapped in sellotape,
it was the studio's stationery
cupboard that provided the
necessary equipment.

Rankin
Male Nudes

Many thanks to Sandra, Pauline, Jamie, Elissa, Guy, Laurie, Matt, Seto, Karen and everyone at Rankin Photography. Helen Walker and Elizabeth Hoff for helping out. Jan, Kathy, Sian, Mark, Leah and everyone at ESP. René Hauser. Jacqui Wald and all at Camera Press. Chico Lowndes. Lisa Houghton, Shinya Nakayama and all at Untitled. Rebecca Kerr and Emma Miles for the great body painting. Kirk, Dan, Zoe, Diana, Sarah, Lisa, Emily and Steve at Vision On. Alex, Alan and Nina at Proud Galleries. Kerin, Lee, Jo, Tony, Ian and all at Joe's Basement. Colin, Belinda, Lucy, Rory and all at Shoemakers Elves. Alex Betts. Hector, Lauren and all at Idea Generation. Bryan, Carsten and all at SEA. James Rudd and Aubrey Croal at Argent Colour. Colin Passmore, Lee Deacon and all at Godfrey Lang. All at Book Print in Barcelona. Susanne and all at Dazed for their patience and help, especially Laura Hastings-Smith. Michael Proudfoot, Chris Cottam, Simon Allen and all at Uden Associates. Erica Boardman, Kate Husher and everyone at the Institute of Cancer Research. Jayne and Rosalie at Jayne Collins Casting. Dominy and all at Nevs. Andrew Tuck and Roger Morton for their help with the index.

Special final big thank you to all the men who had the guts to apply and be photographed for this project, and Briar who is the greatest person in the world.

Male Nudes first published in Great Britain in 2001 by Vision On Publishing Ltd 112 – 116 Old Street London EC1V 9BG

Telephone +44 207 336 0766 Facsimile +44 207 336 0966

www.vobooks.com info@vobooks.com

First published in the United States of America in 2001 by Universe Publishing, a Division of Rizzoli International Publications, Inc. 300 Park Avenue South New York, NY 10010

Library of Congress Catalog Card Number 2001086934

ISBN 0 7893 0621 2

Photography
Rankin

Design/Art Direction
SEA

Managing Editor
Zoe Manzi

Creative Director
Kirk Teasdale

Project Manager
Briar Pacey

Production
Steve Savigear
Emily Moore

Reprographics
Argent Colour

All prints
Joe's Basement

Print
Book Print, Barcelona